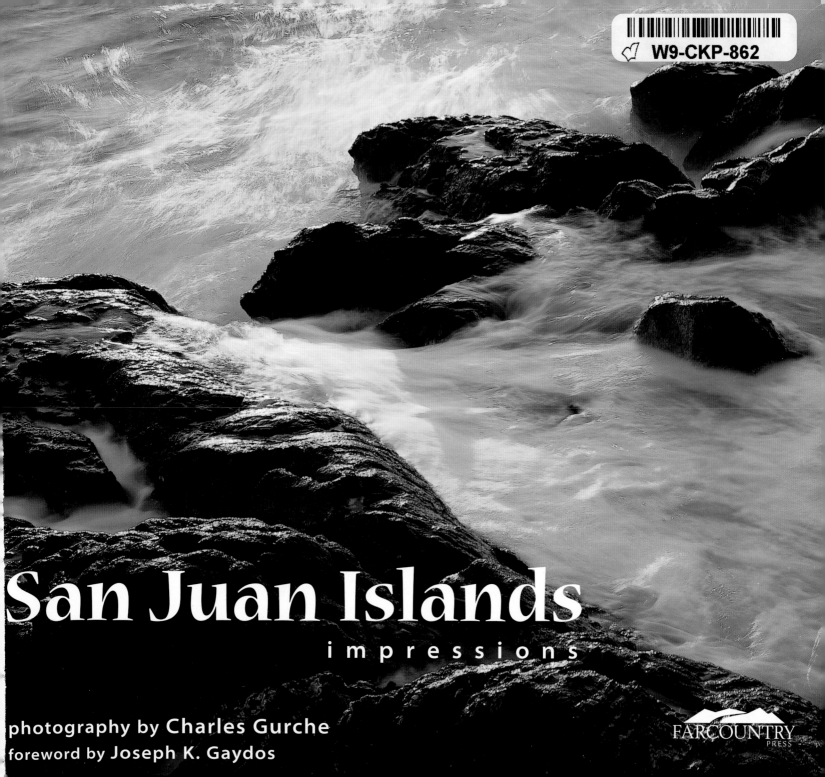

San Juan Islands
impressions

photography by Charles Gurche
foreword by Joseph K. Gaydos

FARCOUNTRY PRESS

I am deeply grateful for Randy Gaylord's help, and for his friendship and excellent boat tours. Thanks to Marny Gaylord, Bob Maynard, and Nancy Maynard for their assistance and support.

Front cover: Climb up Mount Constitution in Moran State Park on Orcas Island for this sweeping view of neighboring islands.

Back cover: A tangle of fishing nets lies on the back of a boat in the quaint, historic fishing village of Friday Harbor on San Juan Island.

Title page: Surf crashes against the rocky coast of San Juan Island.

Right: A sailboat plies the waters near San Juan Island.

Below: Stones collect on South Beach, the longest stretch of public beach in the San Juan Islands.

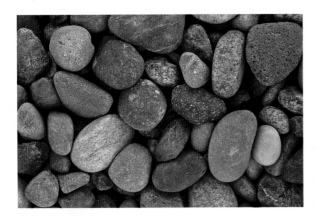

ISBN 10: 1-56037-382-2
ISBN 13: 978-1-56037-382-7

Photography © 2006 Charles Gurche
© 2006 Farcountry Press

For more information on our books write Farcountry Press, P.O. Box 5630, Helena, MT 59604; call (800) 821-3874; or visit www.farcountrypress.com.

Created, produced, and designed in the United States. Printed in China.
11 10 09 08 07 06 1 2 3 4 5

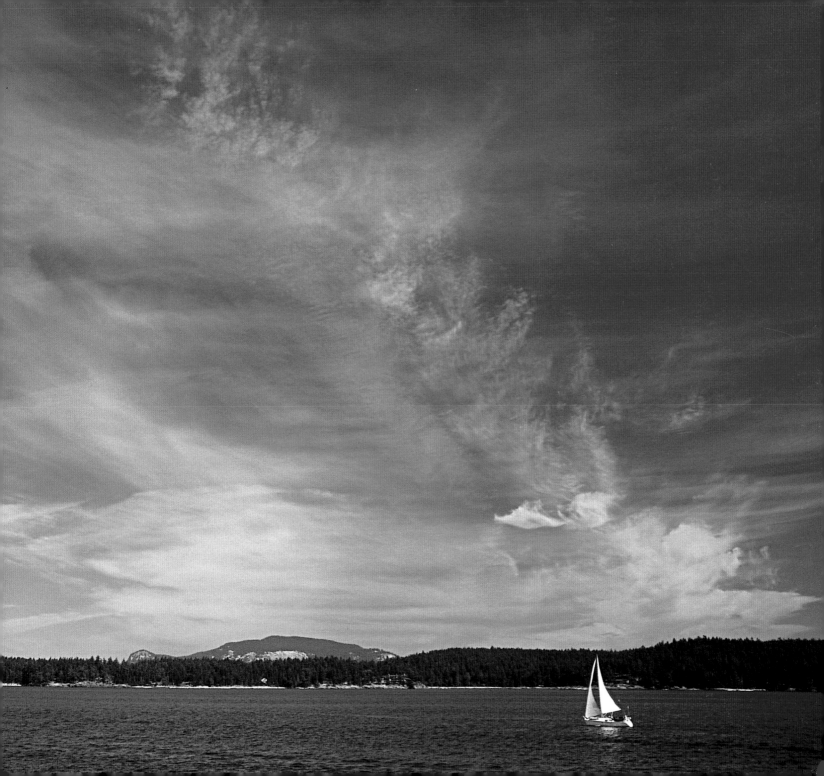

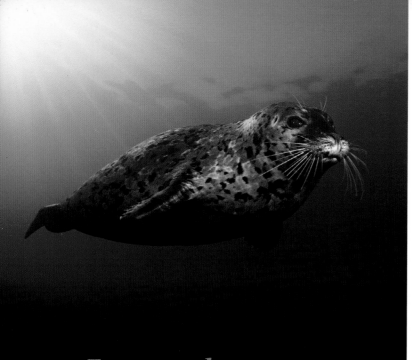

Foreword

by Joseph K. Gaydos, wildlife veterinarian and regional director of The SeaDoc Society, a marine ecosystem health program through the UC Davis Wildlife Health Center.

Harbor seals are quite common in the San Juan Islands. They can remain underwater for more than 30 minutes, but usually only dive for 3 to 4 minutes at a time. BRANDON COLE PHOTO.

*L*ocated in Washington's inland sea, nestled between Vancouver Island and the mainland, are the glorious San Juan Islands—a national treasure.

Despite their proximity to Washington's coast, the islands are geologically distinct from the mainland. Plate tectonics moved rock (created by volcanic activity at the equator) to the islands' current location. Rocks that shifted beneath the edge of the North American continent emerged to meet the volcanically produced rock. Glaciers later scoured the region, and the results are the mountains, glacial plains, gently rolling hills, and deep marine channels we now call the San Juan Islands.

After the glaciers receded 10,000 years ago, people began to settle in the area. Salish-speaking tribes were the islands' first inhabitants. The region's rich marine resources supported large numbers of Salish people. Remnants of multi-family longhouses, in which more than 1,000 people resided, have been found on the islands.

Spanish and English explorers mapped the islands during the eighteenth century, and fur traders and missionaries began to arrive in the region by the early nineteenth century. The United States and Great Britain disputed possession of the islands, until a German mediator declared the San Juan Islands to be U.S. territory in 1872.

Up until the late 1970s, the islands were inhabited by small numbers of homesteaders who depended on farming,

fishing, and, at times, even smuggling and rum running. As bustling urban and suburban lifestyles slowly replaced rural life in the U.S., people from all over the country began to move to the San Juan Islands—a place that offers natural beauty, a well-maintained connection to the land and sea, and a slower pace. In the 1970s, the resident population of the archipelago doubled and has since steadily increased. Because of their social and economic relationships with neighbors, relative isolation from the mainland, and fierce appreciation for the region's natural resources, the islands' full-time residents uphold a strong sense of community and place.

In addition to the scenic pastoral vistas and friendly locals, the diversity of the region's marine wildlife is what makes the San Juan Islands a national treasure. Species richness (the number of different species within a certain area) is one of the most straightforward ways to measure biological diversity. A recent project counted 19 mammal species, 102 bird species, and 177 fish species that depend upon the region's marine waters.

The San Juans boast a fascinating and eclectic group of wild creatures that have adapted to the unique environment. Harbor seals are one of the most common marine animals in the area. The San Juan Islands are home to one-third as many harbor seals as people! Seals are able to drop their heart rate from around 100 beats per minute to just 10 beats in order to dive to depths of 600 feet and stay submerged for more than half an hour. Eight of the 102 marine bird species in the region are alcids (Northern Hemisphere relatives of the penguin). Like penguins, they use their wings to "fly" underwater as they pursue a variety of bait fish that inhabit the rich marine waters. Twenty-one of the 177 fish species found in the San Juans are rockfish, which give birth to young rather than lay eggs—and the older they get, the more young they produce. Invertebrates are just as fascinating. For example, recent research has shown that red urchins can live to be well more than 100 years old! New scientific discoveries continue to shed light on this remarkable region and its wildlife.

The San Juan Islands are inhabited and visited by people who love its history and rich marine life. From this love comes a passion to protect. The work that citizens and multiple unique organizations are doing to preserve the San Juan Islands as a national treasure serves as a model for other regions of the world facing similar pressures at the interface between our oceans and a growing human population.

Enjoy the stunning images in this book. May they inspire you to explore and learn about the San Juan Islands—and help protect this remarkable place.

Right: Fog creeps into a forest of Pacific silver fir in Moran State Park on Orcas Island.

Far right: Moran State Park is home to several waterfalls, including stunning Cascade Falls.

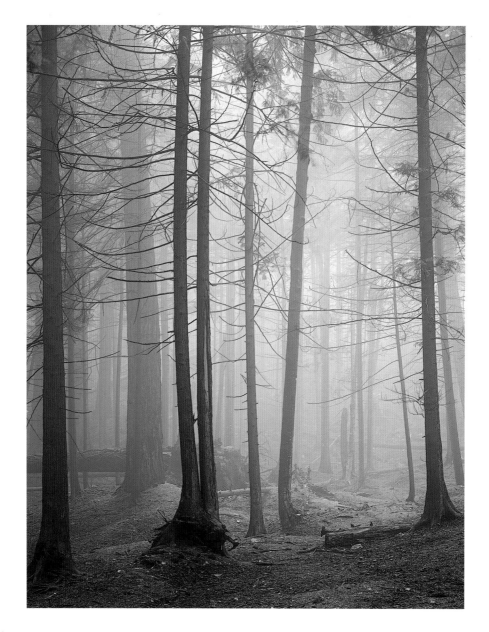

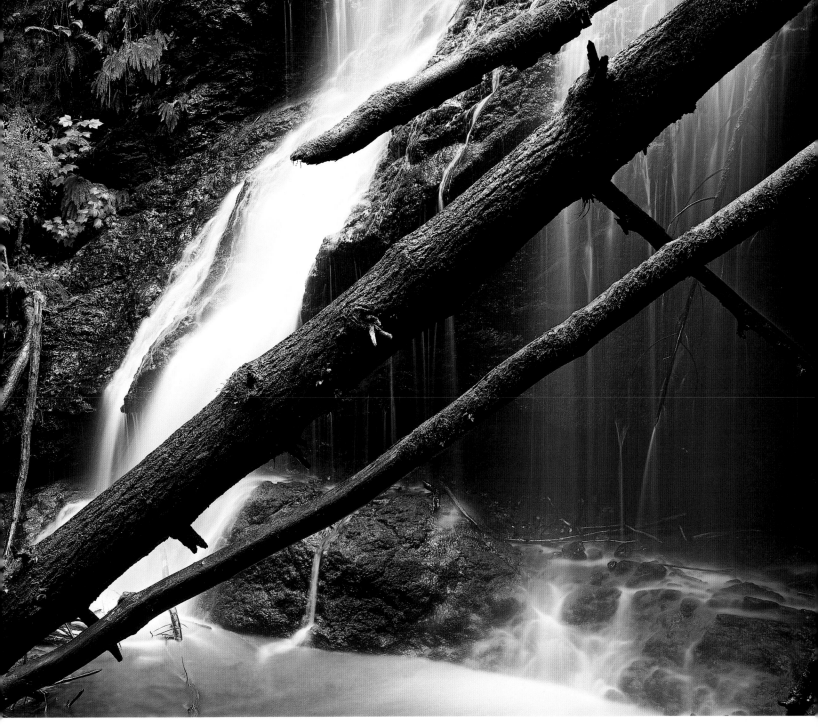

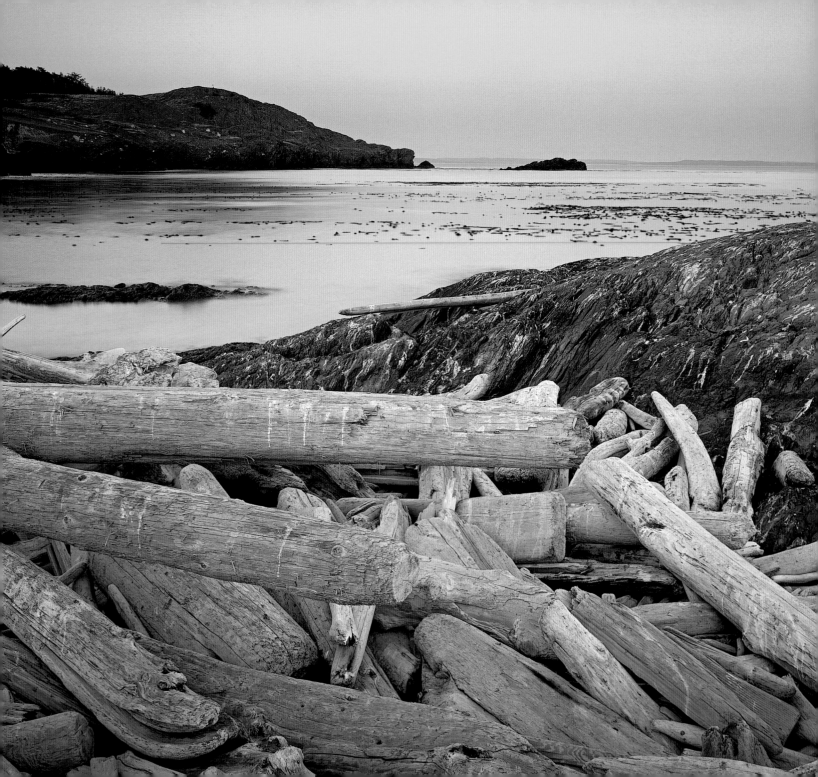

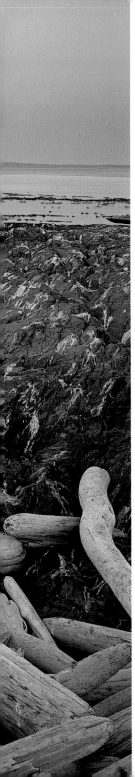

Left: Driftwood accumulates on the south shore of Lopez Island.

Below: A sailboat tours the waters around Henry Island, which is northwest of San Juan Island.

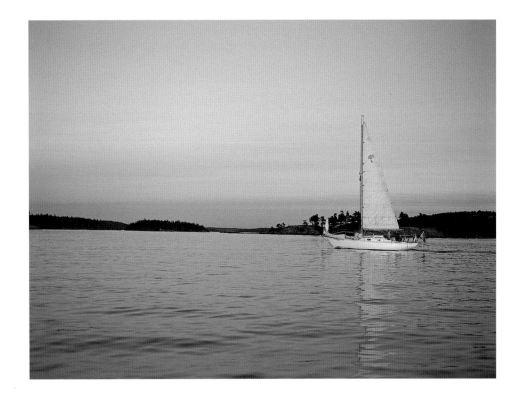

Right: Barnes and Clark Islands appear in the foreground in this early morning view from atop Mount Constitution in Moran State Park on Orcas Island.

Below: Italian mouflon sheep, relatives of bighorn sheep, roam Spieden Island.

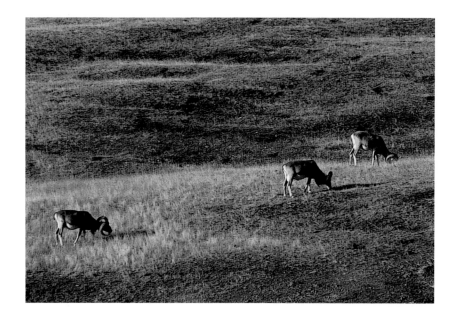

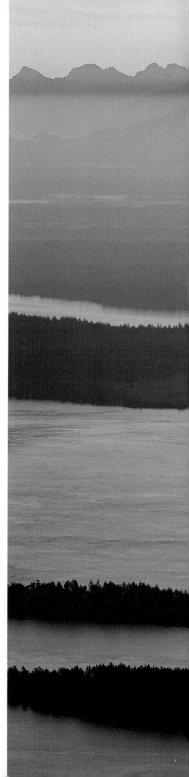

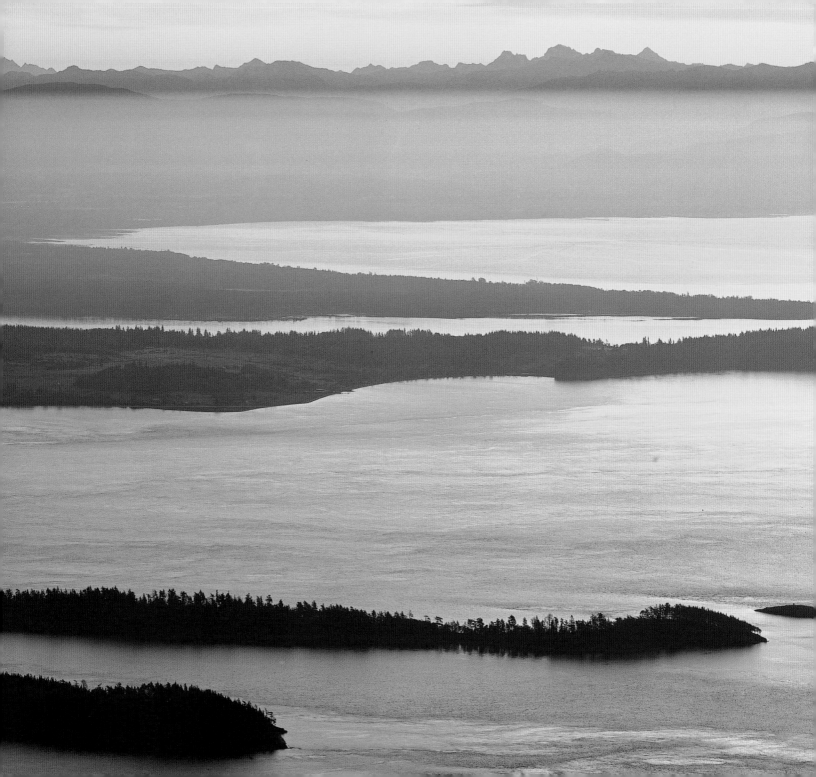

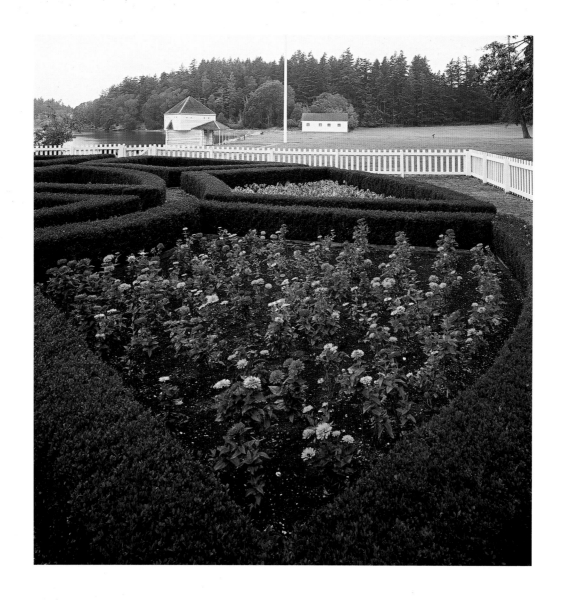

Above: This formal garden is part of the English Camp in San Juan Island National Historical Park. Great Britain and the United States each believed they owned the San Juan Islands. The two nations agreed to jointly occupy San Juan Island until ownership was determined. Two camps were created on opposite sides of the island, the English Camp in the north and the American Camp in the south.

Facing page: Lopez Island, home to farmhouses like this one, is mostly rural, with flat pastureland and rolling hills.

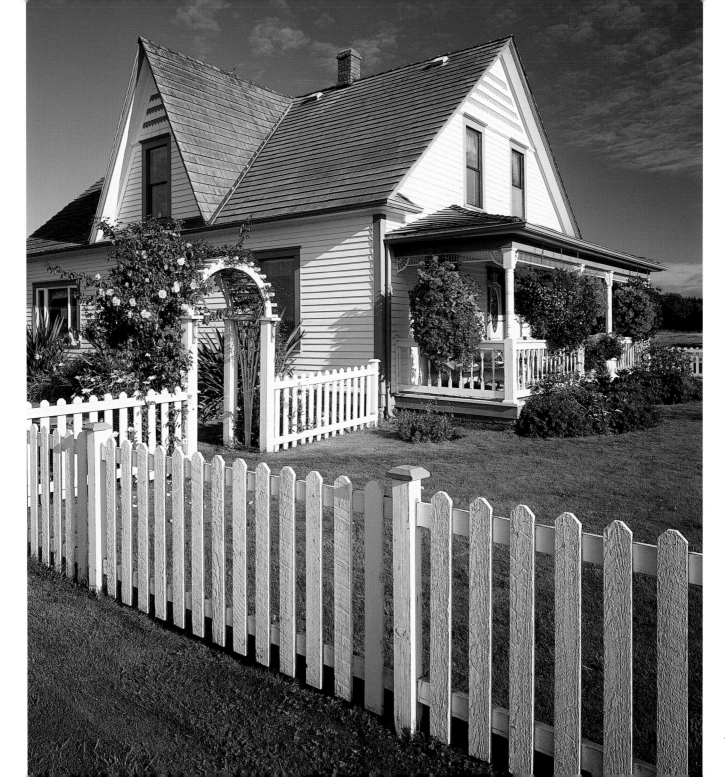

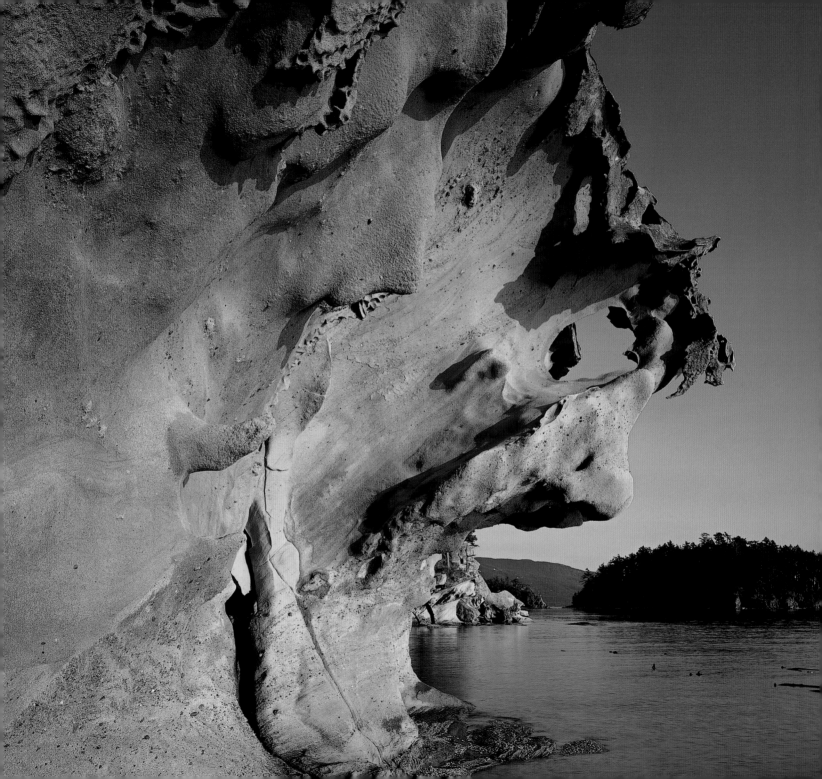

Left: Sandstone formations reach out over the water at Sucia Island, north of Orcas Island.

Below: A restored ship called the *Flying Dragon* makes a stop in Roche Harbor at San Juan Island.

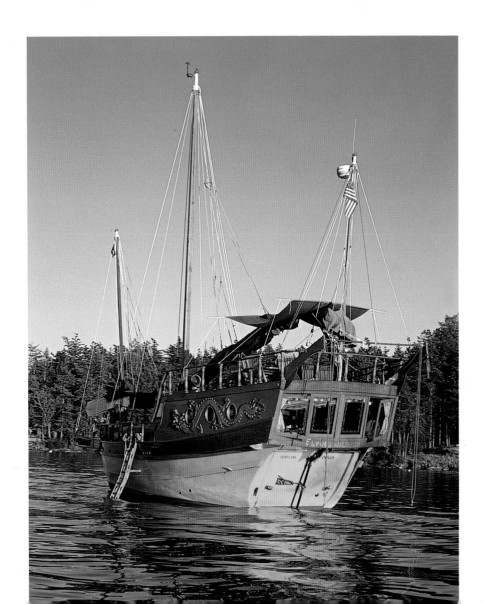

Right: Autumn colors are reflected in a glassy pond on San Juan Island.

Below: Colorful stones cover Agate Beach on the south end of Lopez Island.

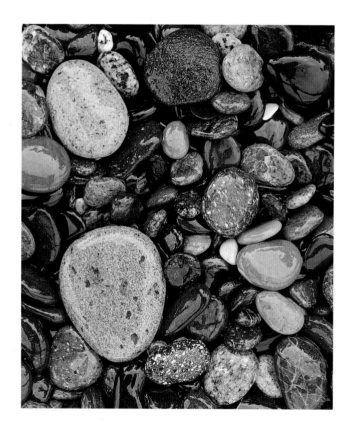

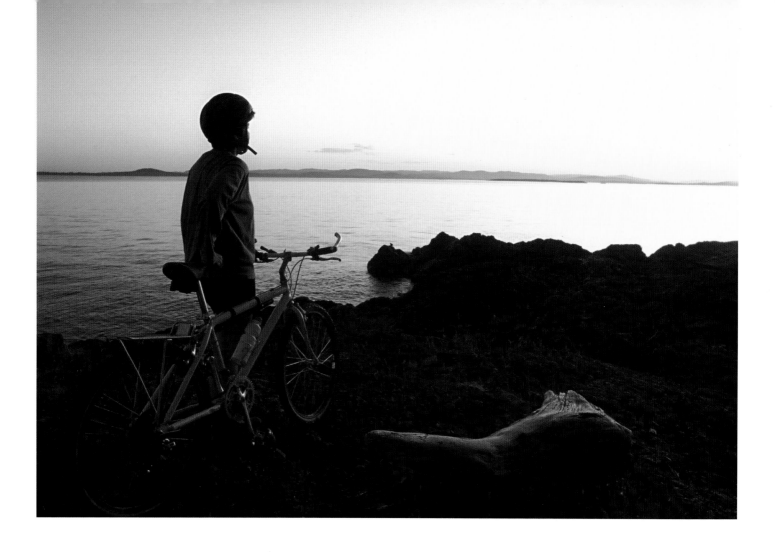

Above: A cyclist pauses to enjoy the view near Cattle Point on San Juan Island. ERIC KESSLER PHOTO.

Facing page: Dawn breaks across the tidal flats at Otis Perkins County Park on Lopez Island. Tidal flats are areas of barren mud that are occasionally covered by tidal waters.

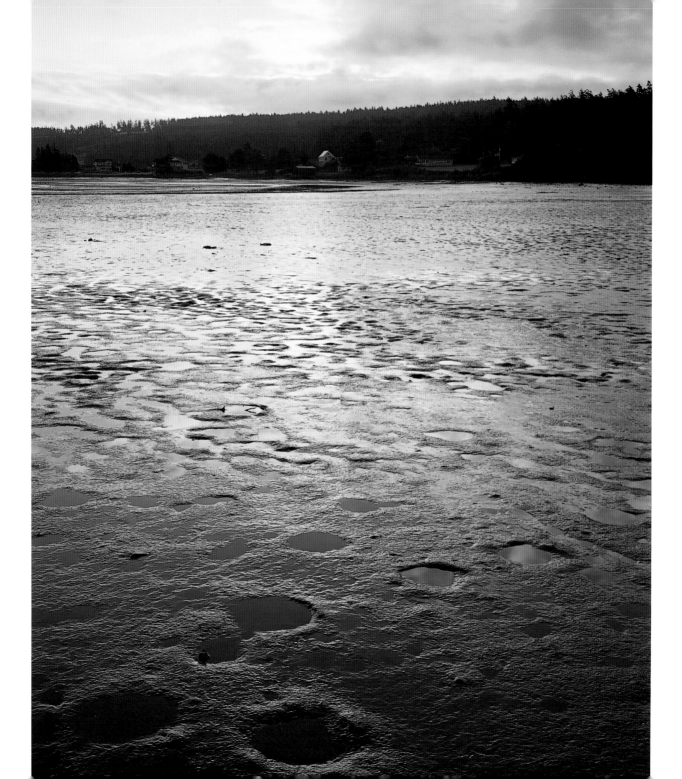

Right: Boats line the docks at Friday Harbor Marina on San Juan Island.

Below: The ferry *Elwha* cruises into Friday Harbor with a full load of passengers and vehicles from the mainland.

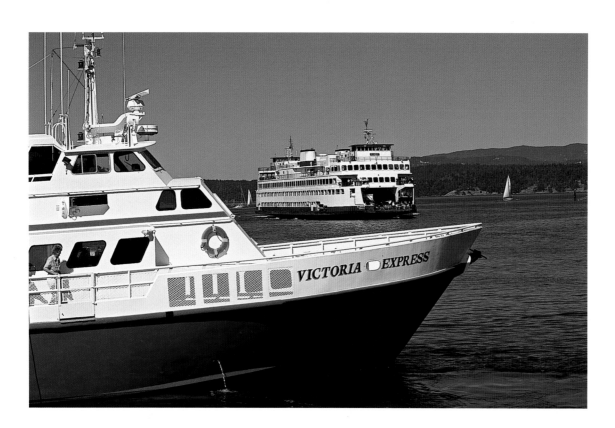

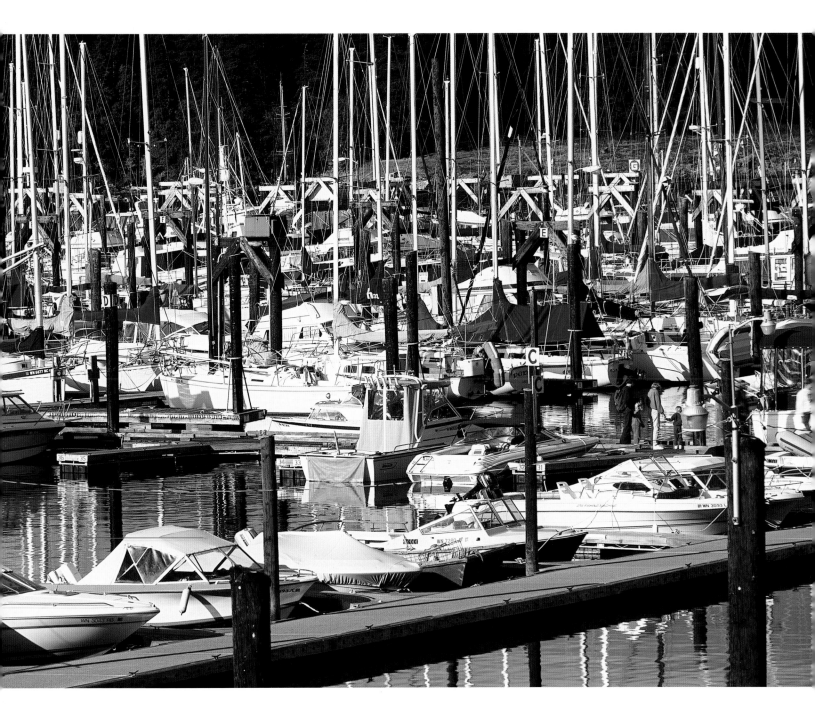

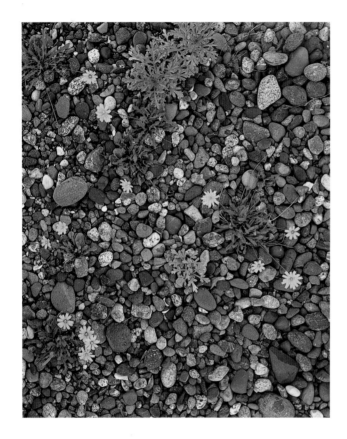

Above: Agoseris grows amid the pebbles on
San Juan Island's South Beach.

Right: Birdsfoot trefoil fills a meadow on San Juan Island.

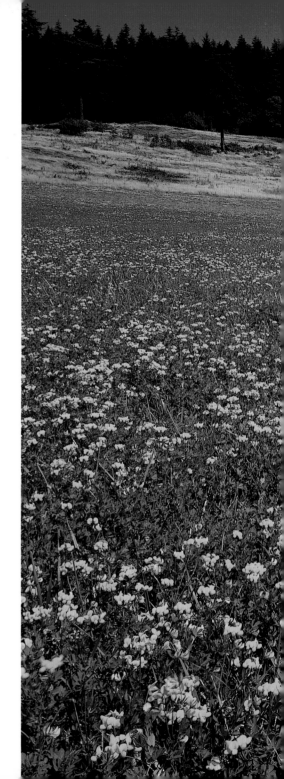

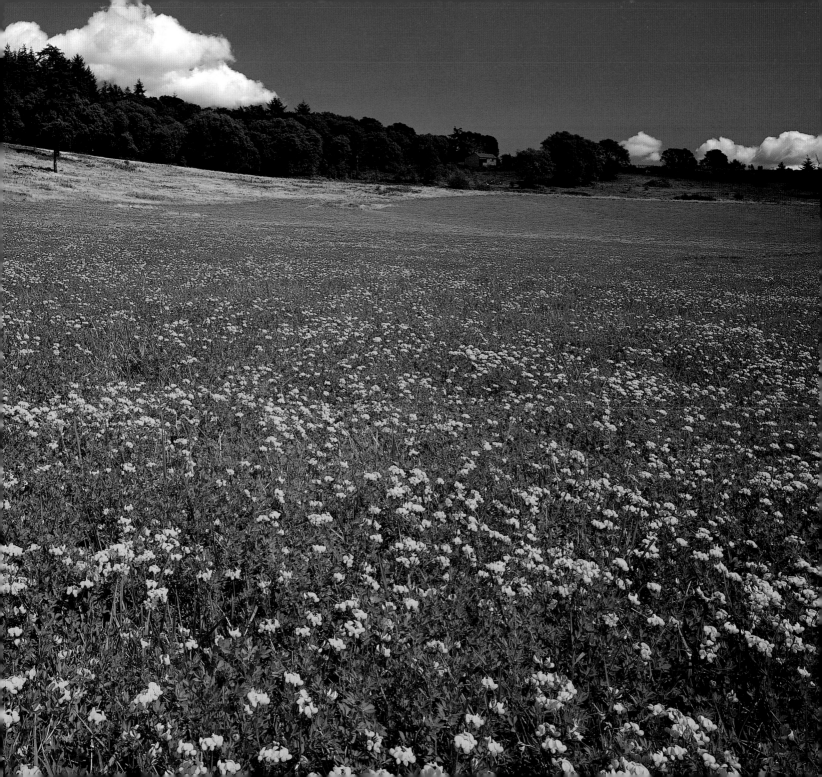

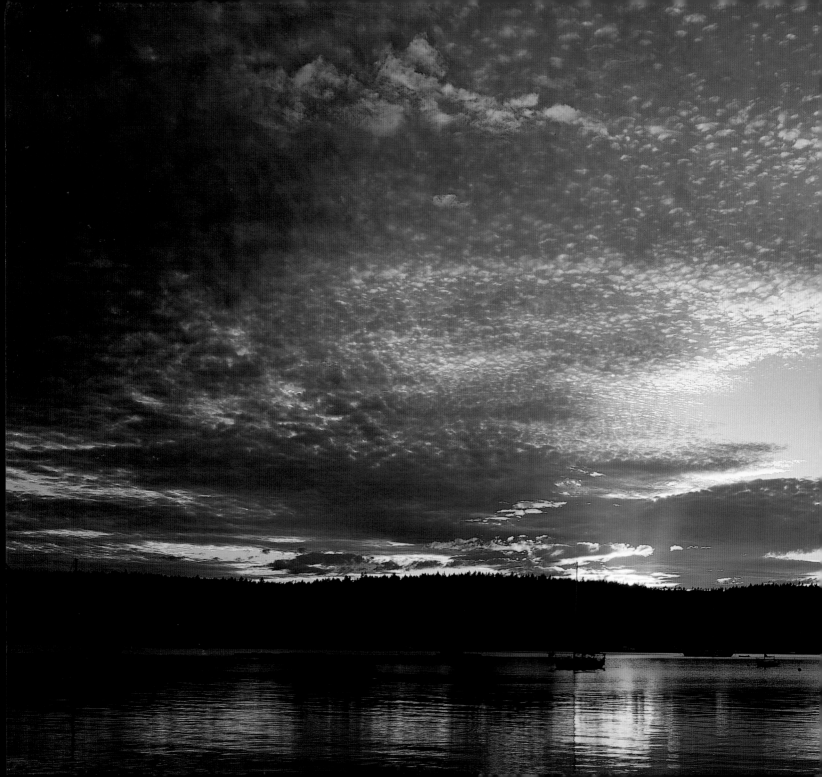

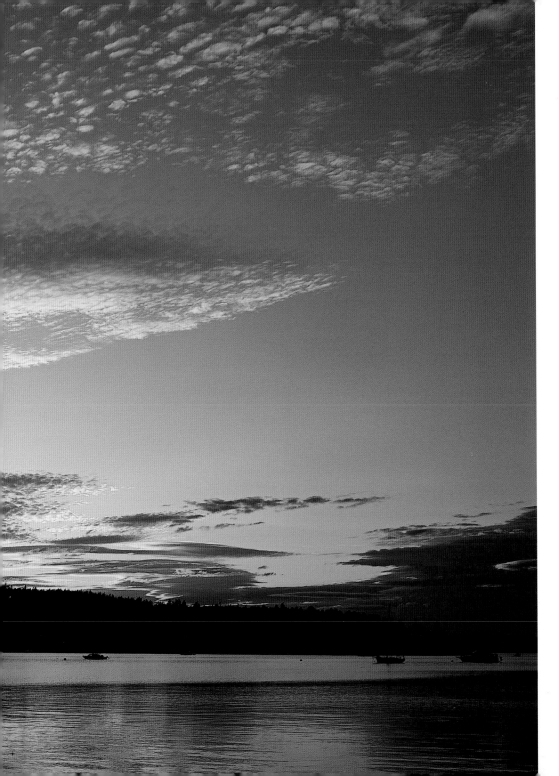

The sun drops behind the hills around Blind Bay at Shaw Island.

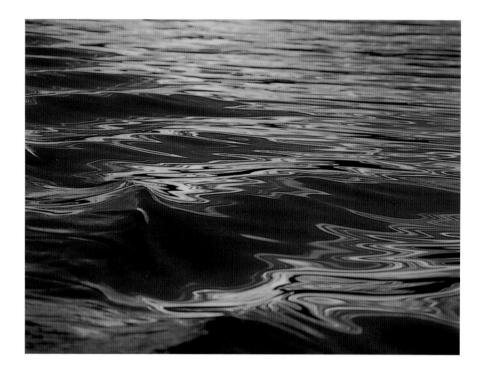

Above: Abstract patterns appear in the water around San Juan Island at sunset.

Right: The Cattle Point Lighthouse in San Juan Island National Historical Park offers exceptional views of the Strait of Juan de Fuca.

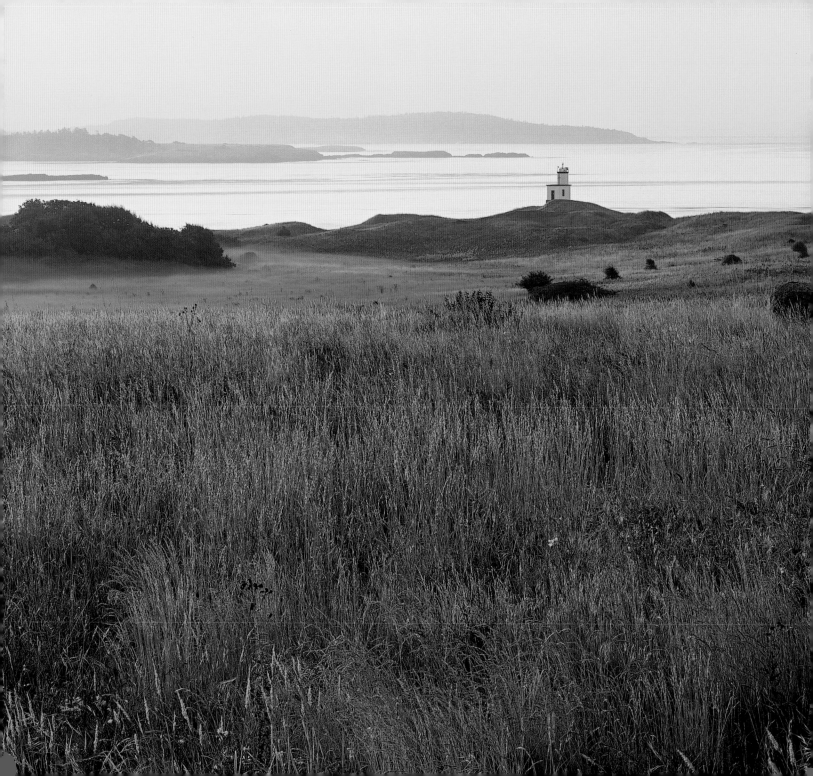

Right: This historic log cabin on Shaw Island was once a post office and is now a museum. Its holdings include documents and artifacts donated by island residents.

Below: A wheel and millstone lean against a historic building at San Juan Island Historical Museum in Friday Harbor.

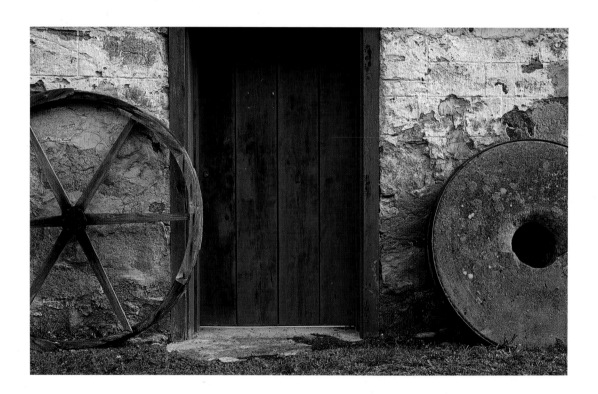

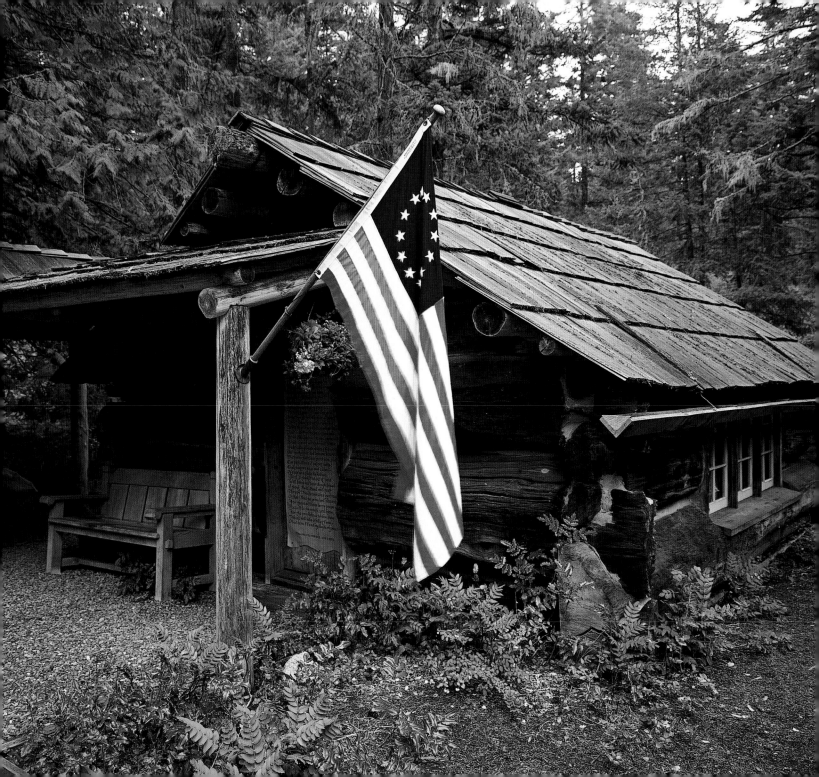

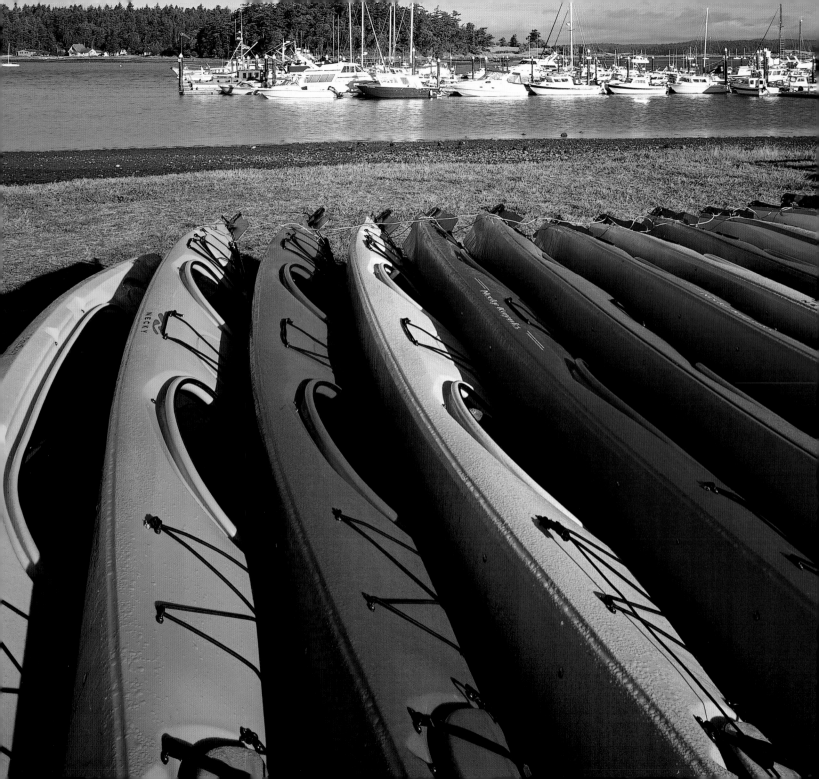

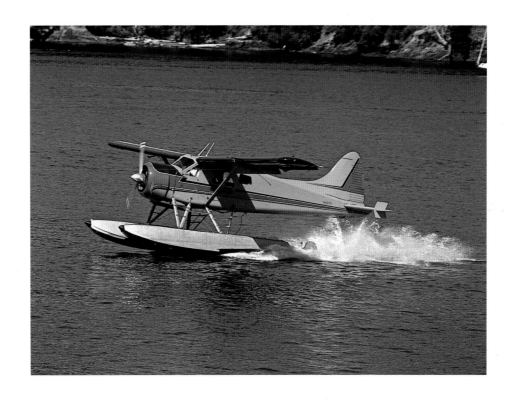

Above: A floatplane touches down in
Friday Harbor at San Juan Island.

Left: Colorful kayaks are moored on shore
at Spencer Spit State Park on Lopez Island.

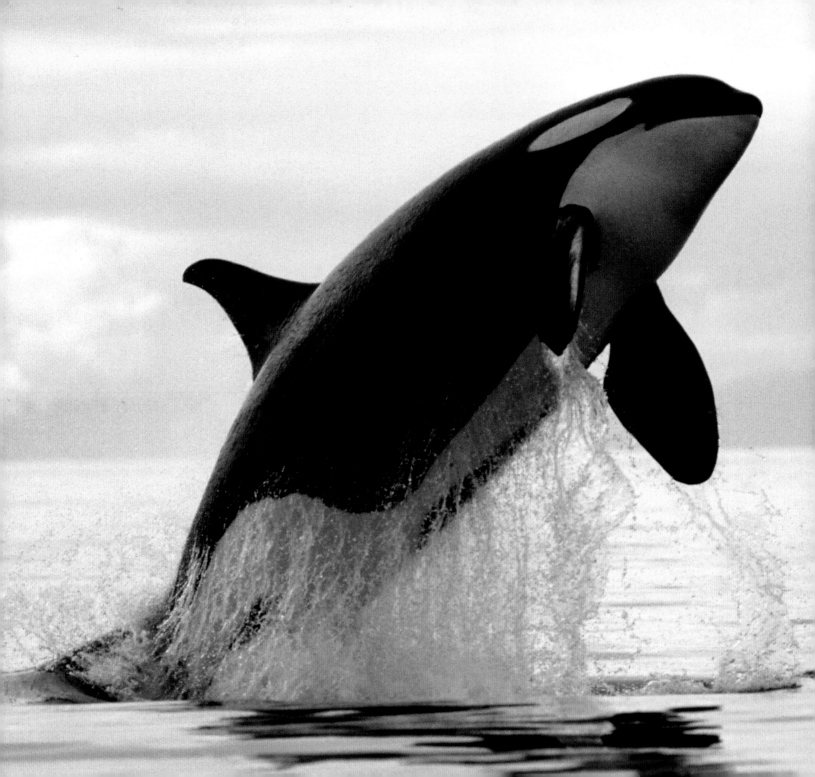

Orcas, the largest members of the dolphin family, commonly leap out of the water, or breach. Nearly 100 orca whales make the waters around the San Juans their permanent home. BRANDON COLE PHOTO.

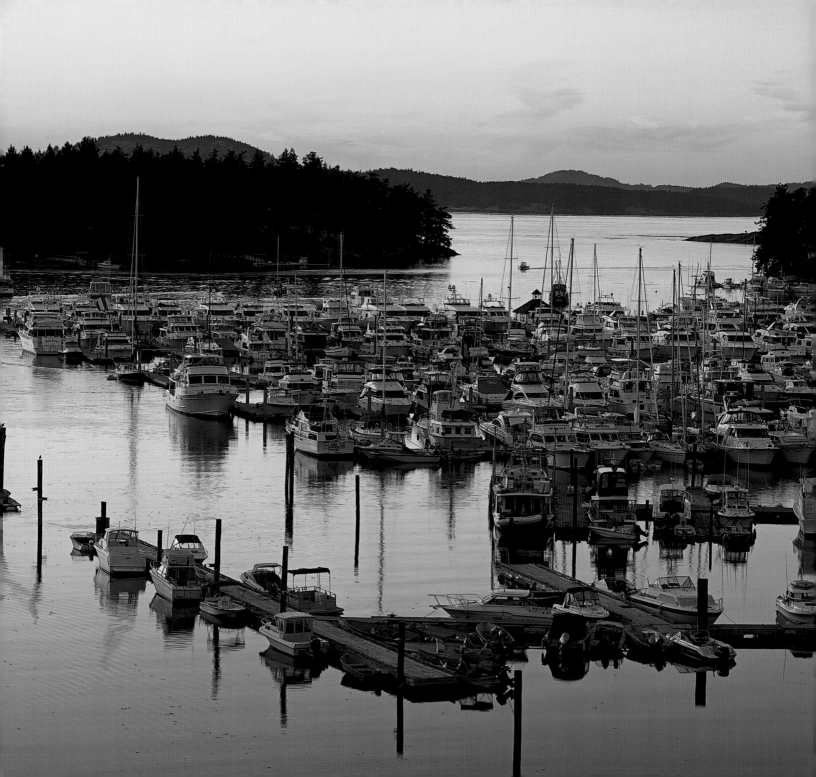

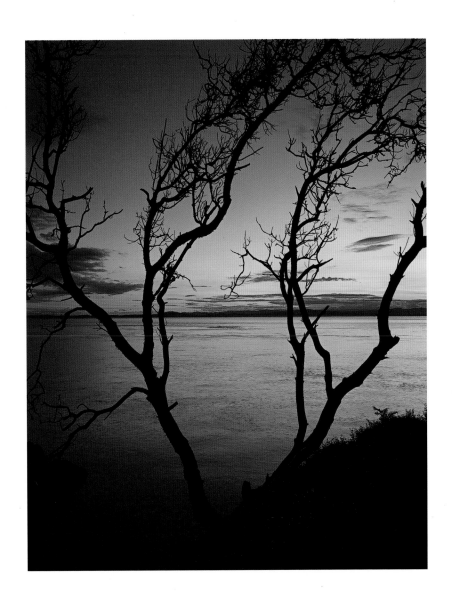

Left: Dusk silhouettes a madrone tree on San Juan Island. Madrones grip the rocky soil along the waterfront and help prevent erosion.

Far left: Roche Harbor Marina at San Juan Island is a popular destination for boaters.

John S. McMillin, founder of the Roche Harbor Lime and Cement Company, built the Afterglow Vista on San Juan Island, a mausoleum to honor his family. Romanesque pillars encircle a limestone table surrounded by seven stone chairs. Missing are one pillar and the chair in front of it—rumored to symbolize one of McMillin's sons who married out of the Methodist religion.

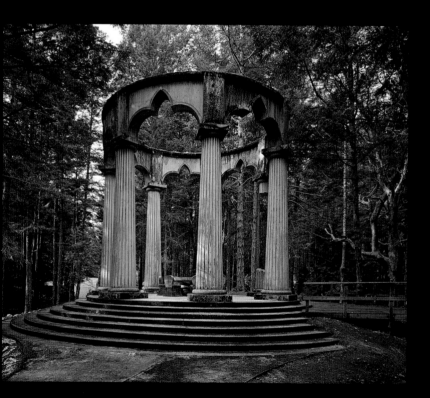

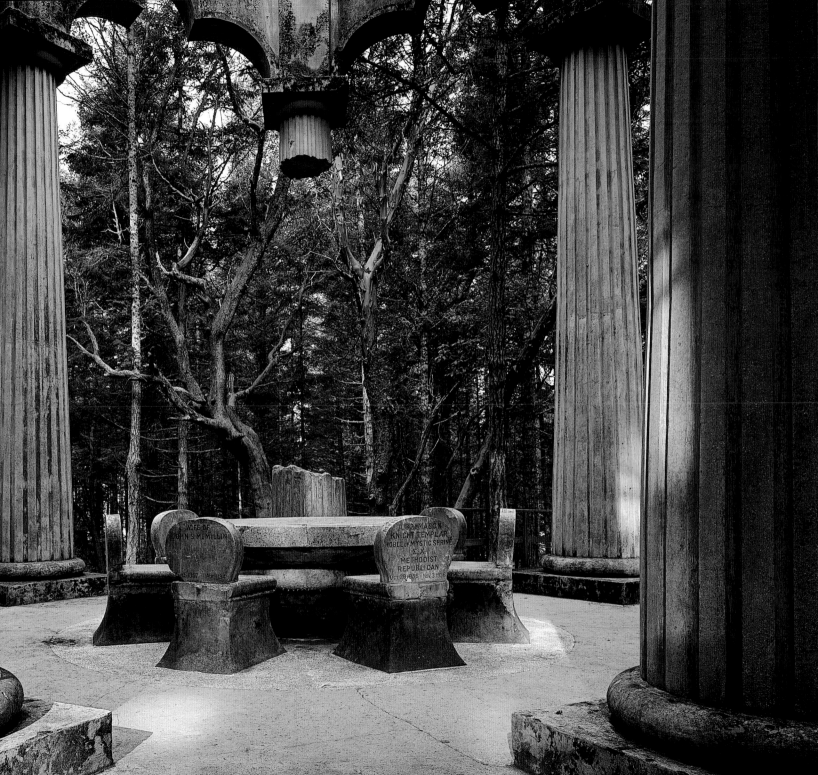

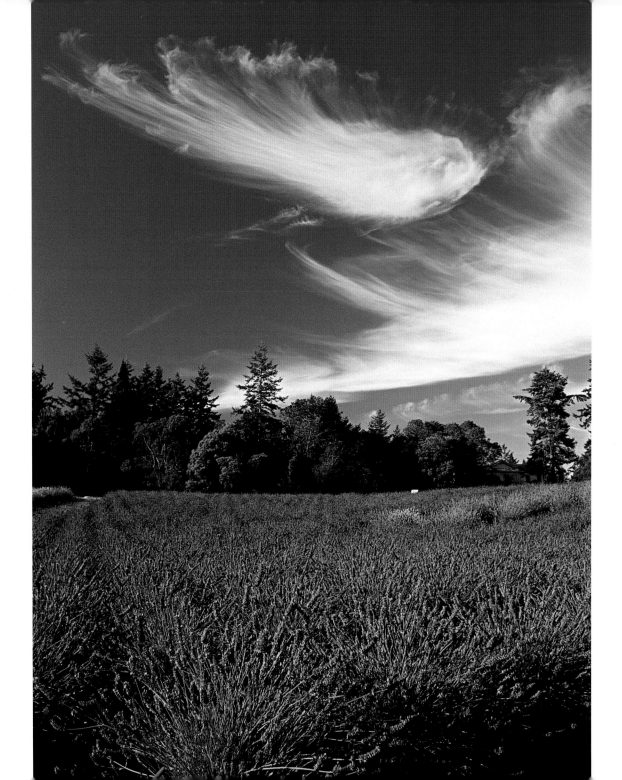

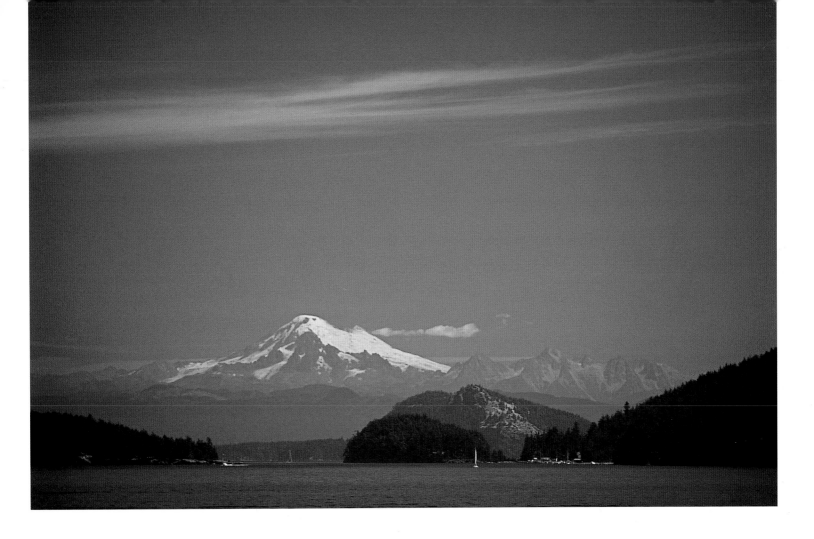

Above: From near Lopez Landing on Lopez Island, snowcapped Mount Baker can be seen across the Rosario Strait.

Facing page: The Pelindaba Lavender Farm on San Juan Island is a premier grower of lavender plants and hosts an annual harvest festival featuring art, music, workshops, and lavender-based food and drinks.

Right: A huge maple tree rises above English Camp on San Juan Island.

Facing page: A quiet road on Shaw Island is scattered with maple leaves.

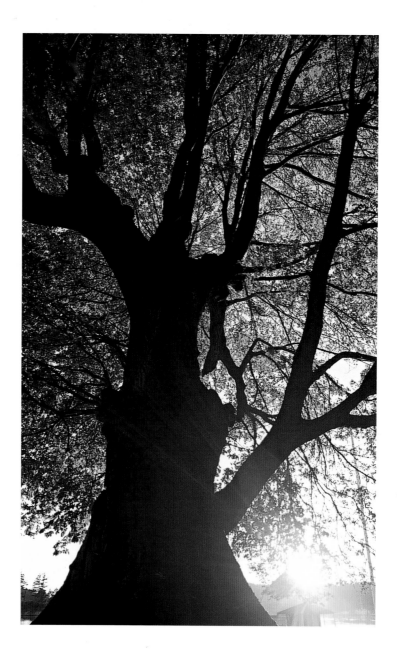

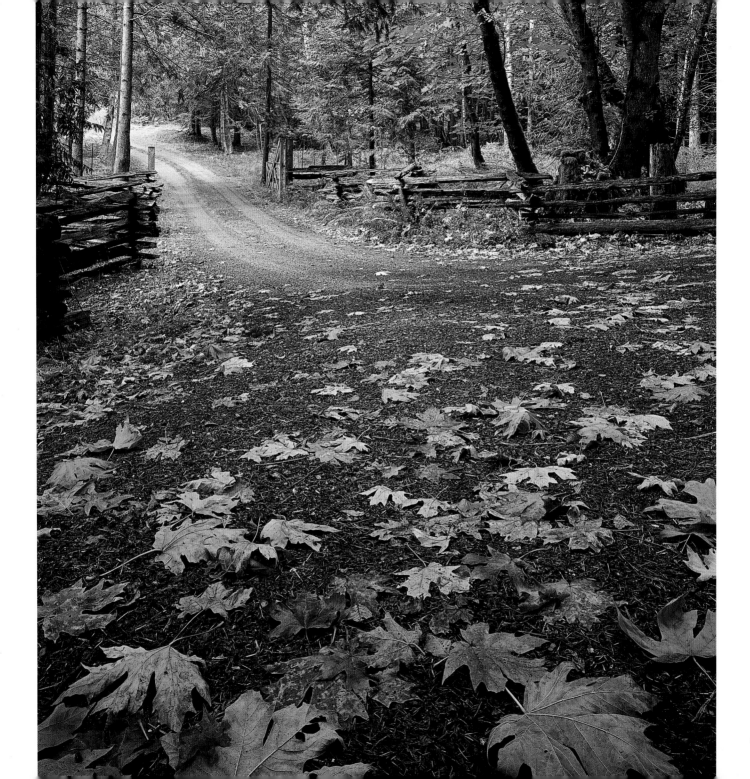

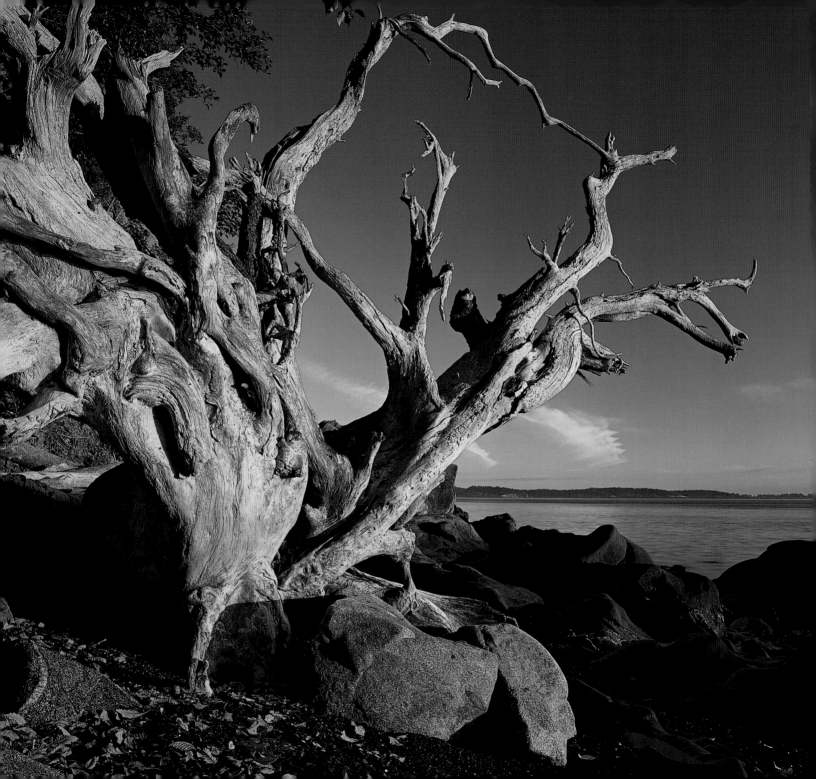

Left: The wild shape of a piece of driftwood is like sculpture on an Orcas Island beach.

Below: On Waldron Island, Point Disney juts out into the ocean. The island does not have public ferry access, yet it supports a small resident population.

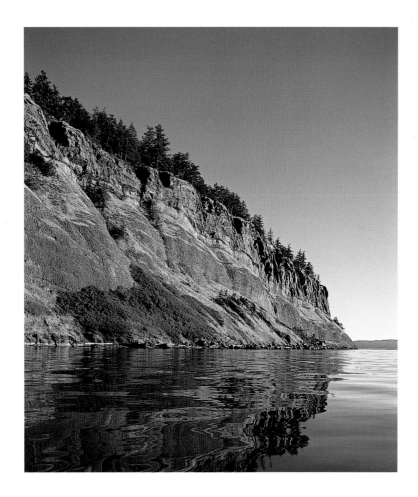

Right: Lime Kiln Point State Park on San Juan
Island is a popular place to spot the orcas that
spend the summer months in Haro Strait.
BRANDON COLE PHOTO.

Below: Sea kayakers enjoy a day of paddling in
Smallpox Bay at San Juan County Park.

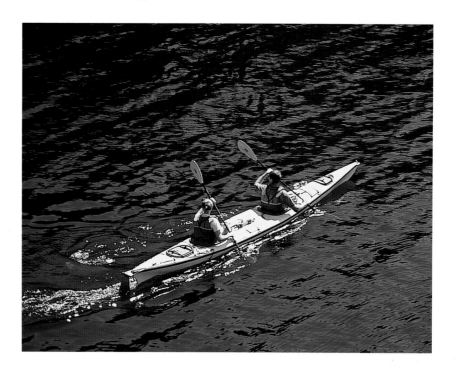

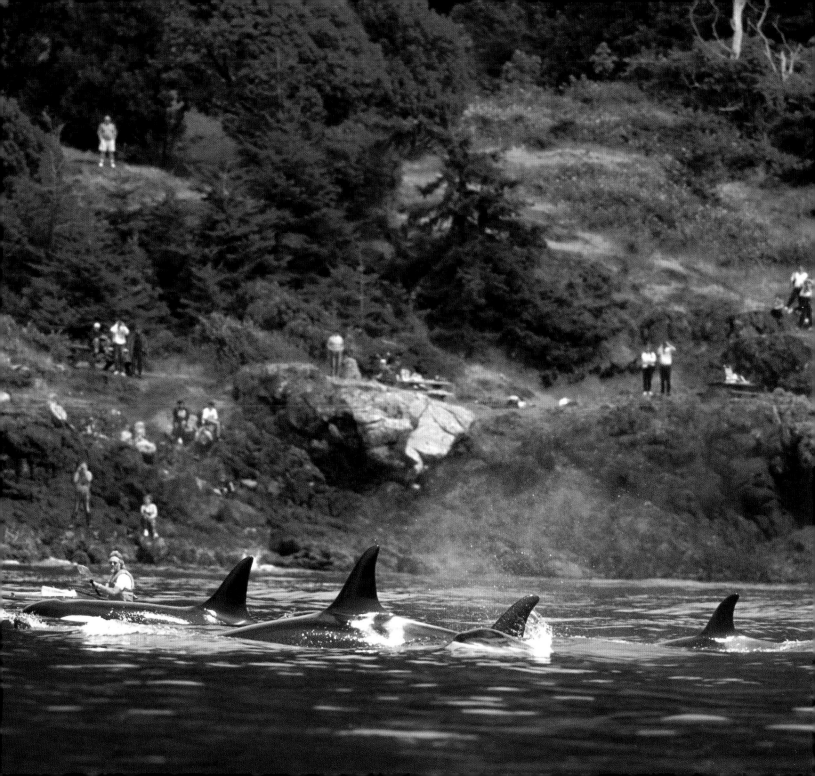

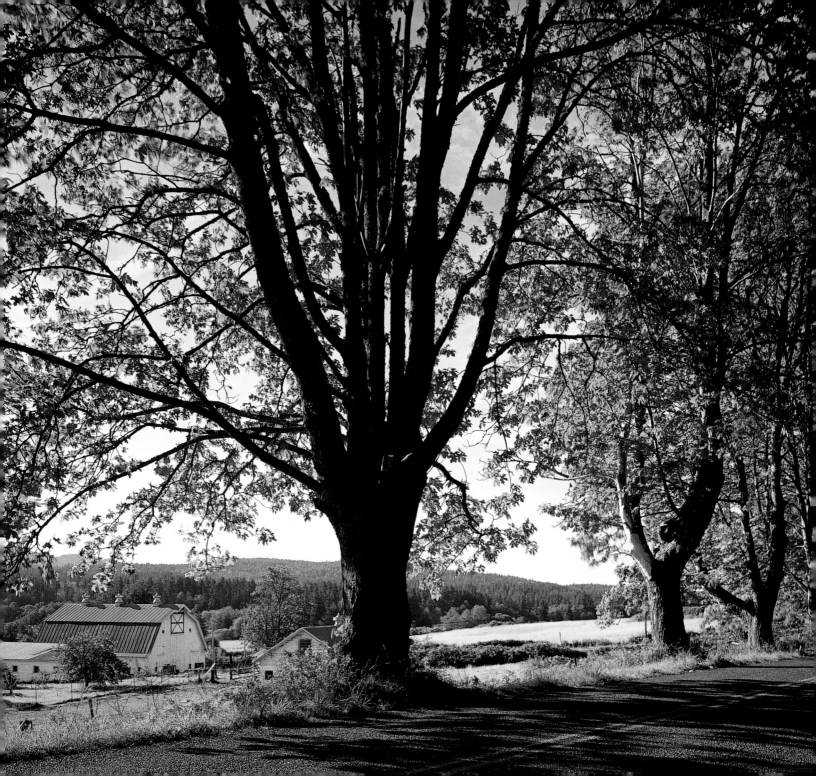

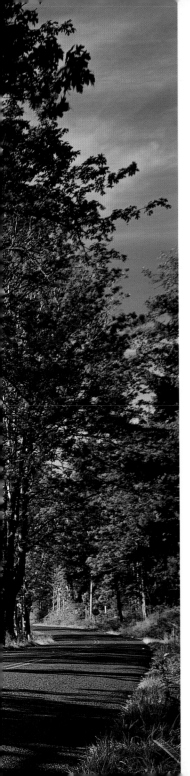

Left: Tree-lined Crow Valley Road meanders through farmland on Orcas Island.

Below: Yellow water lilies spread across twelve-acre Summit Lake in Moran State Park on Orcas Island.

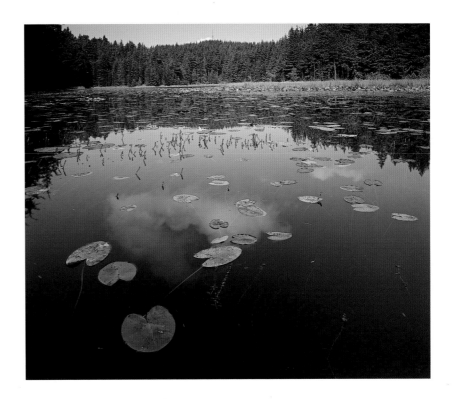

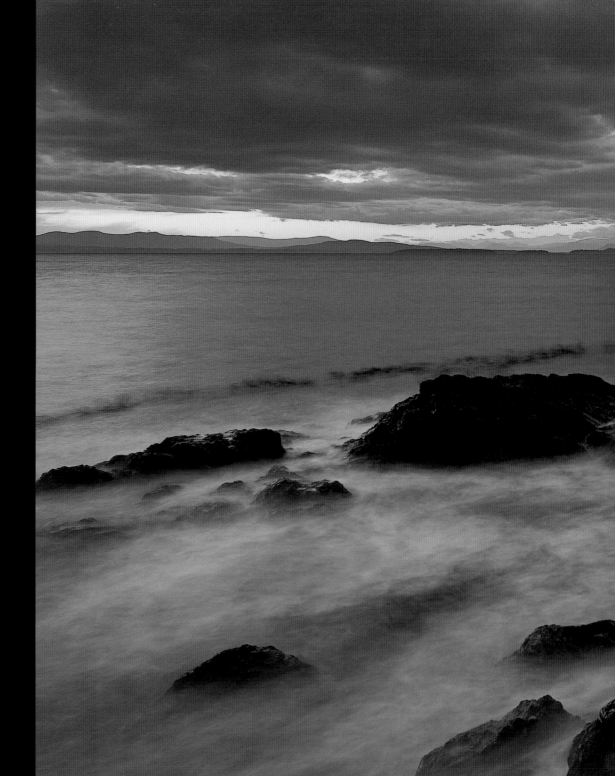

Located on the west side of San Juan Island in Lime Kiln State Park, Lime Kiln Lighthouse overlooks Haro Strait. The lighthouse began operating in 1914 and was automated in 1962. Since 1985, it has been dedicated as a base for scientists who study the movements and behavior of orca whales.

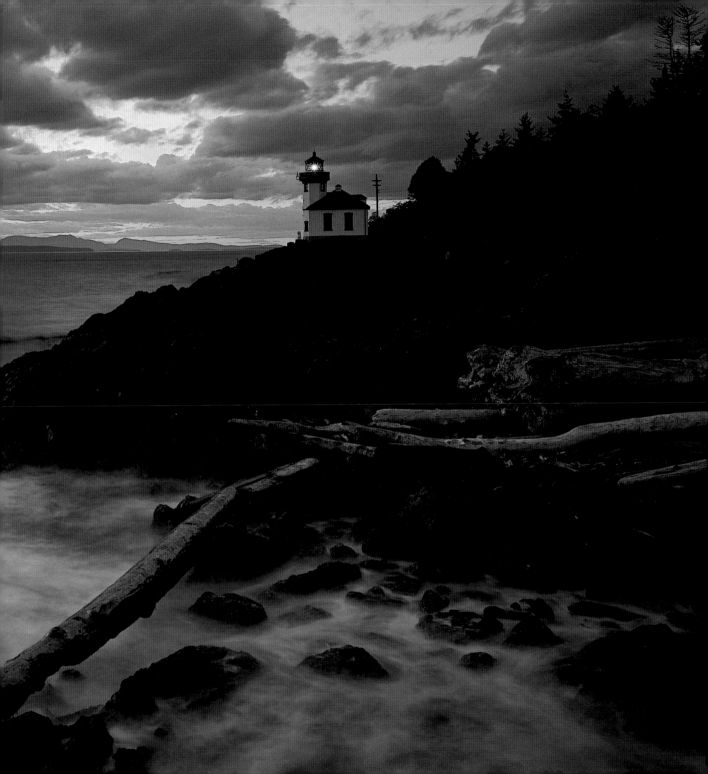

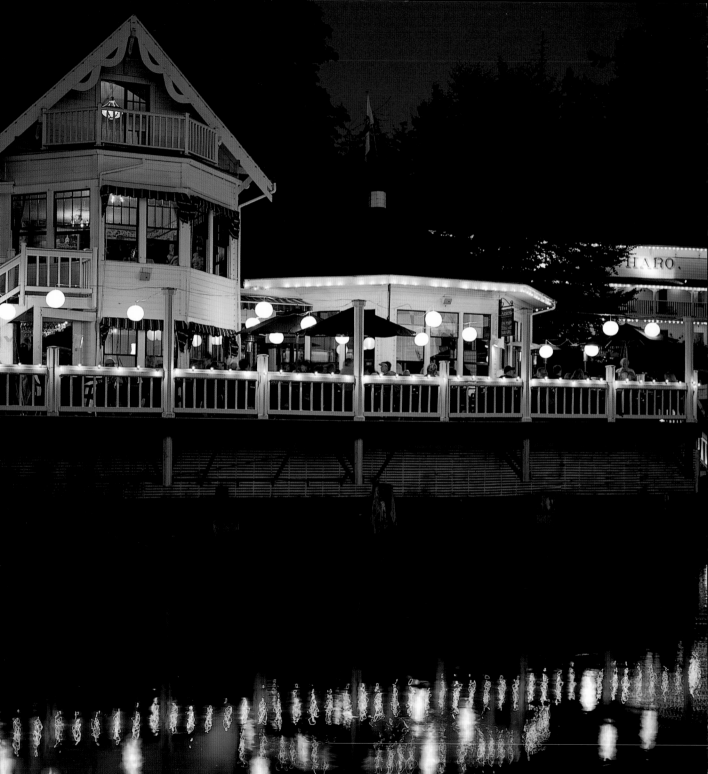

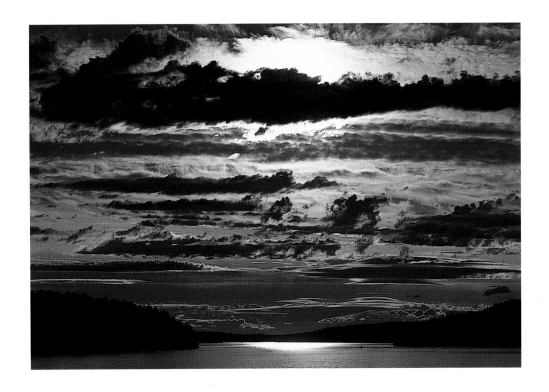

Above: Thatcher Pass is the stretch of water between Blakely Island to the north and Decatur Island to the south.

Left: Roche Harbor Resort and the Hotel de Haro have a rich history on San Juan Island. In the 1880s, John S. McMillin discovered the largest deposit of lime in the Northwest on the island. McMillin built the 22-room Hotel de Haro in 1886, and by the 1890s the town of Roche Harbor had grown up around it.

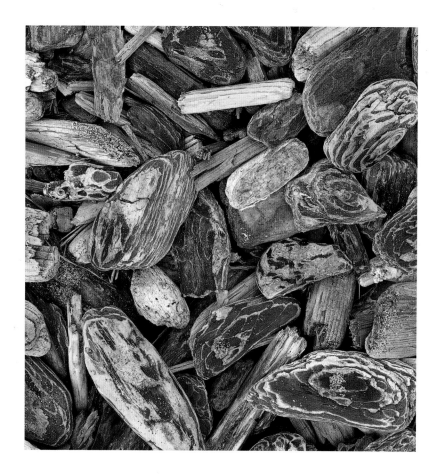

Above: Wave-worn bark collects on the beach at San Juan Island.

Right: Iceberg Point overlooks the Strait of Juan de Fuca at the southern end of Lopez Island.

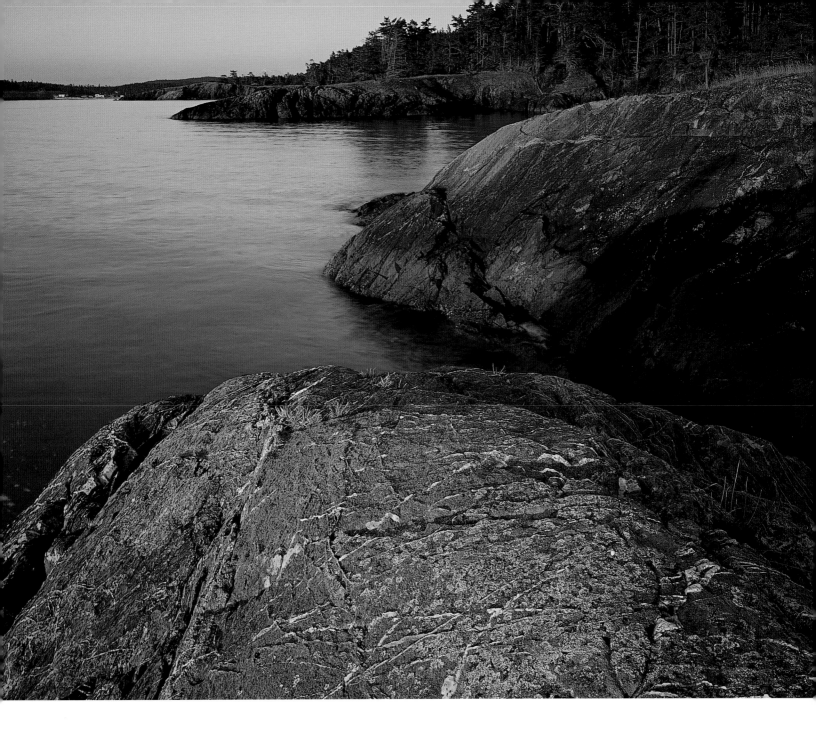

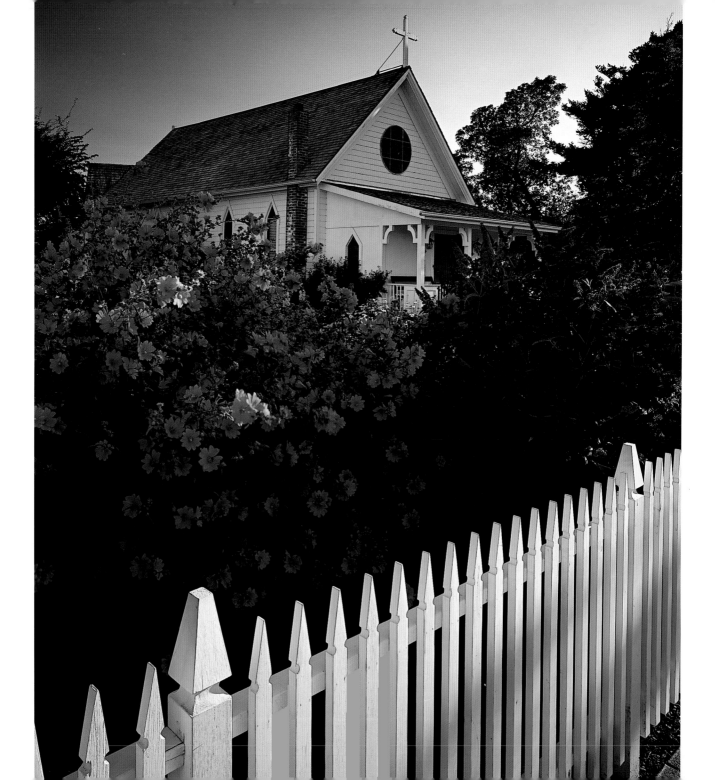

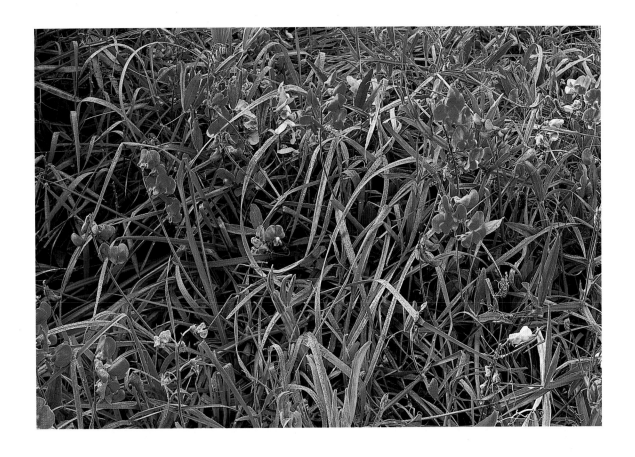

Above: The bright-pink blossoms of wild pea plants appear in spring on Lopez Island.

Facing page: The small rural parish of Emmanuel Episcopal Church in Eastsound was established in 1885 on Orcas Island.

Low tide reveals plant life clinging to the rocks on Buckhorn Beach *(facing page)* and Point Thompson *(below)* on Orcas Island.

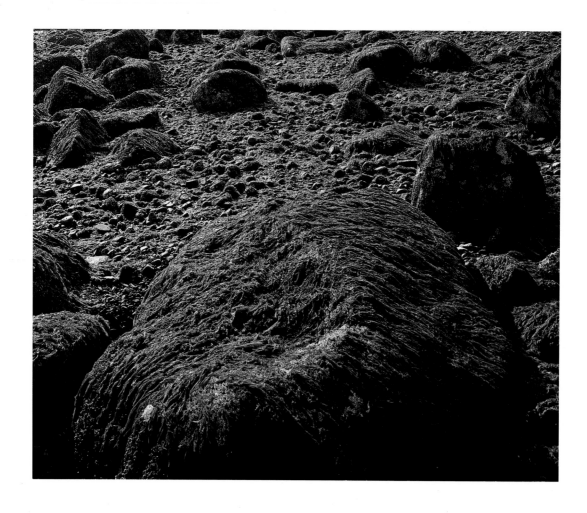

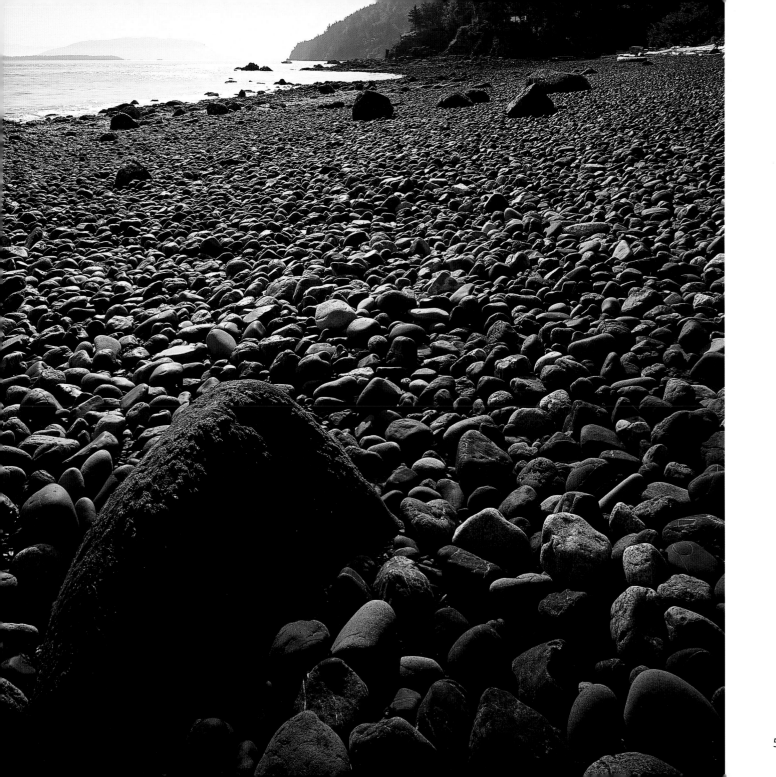

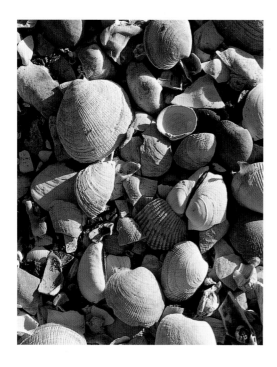

Above: Seashells by the seashore: shell collectors' quarry awaits along Blind Bay on Shaw Island.

Right: With the tide out, colorful starfish appear in tidepools near Olga on Orcas Island.

Facing page: Located between Orcas and San Juan Islands, Yellow Island is a small nature preserve that protects numerous flora.

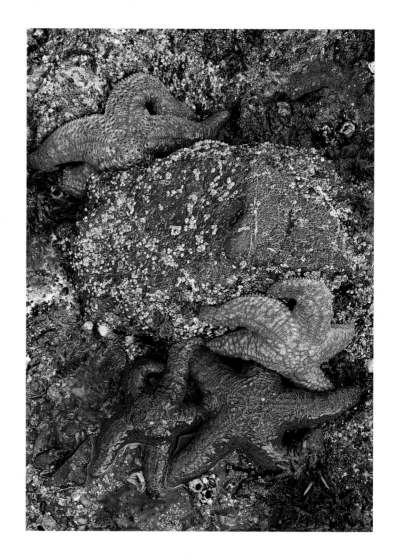

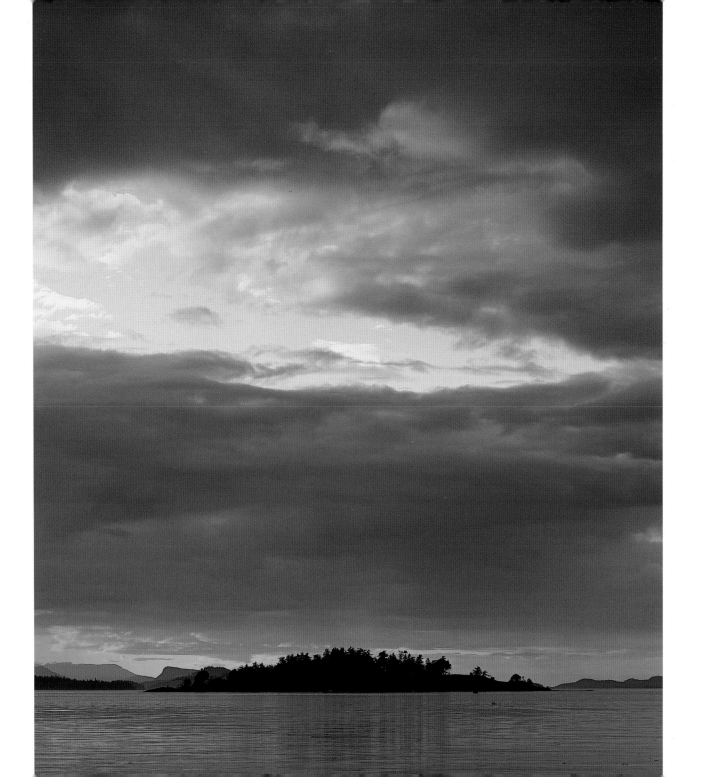

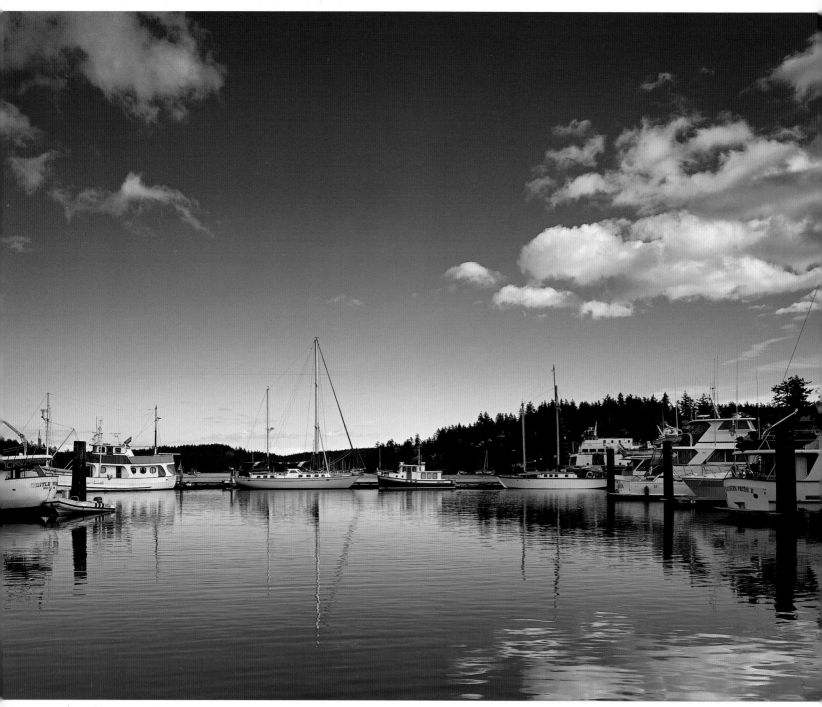

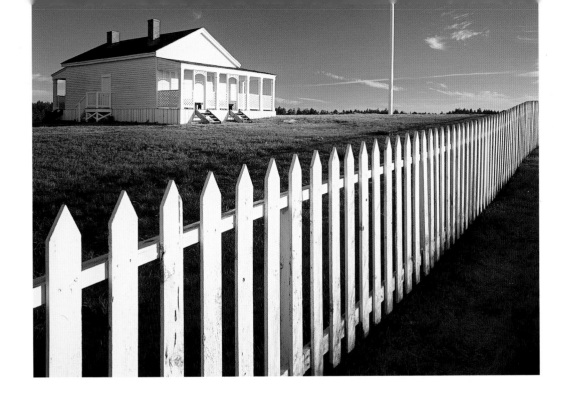

Above: A white picket fence surrounds the Officers' Quarters at American Camp in San Juan Island National Historical Park.

Right: Visitors to Lopez Island often stop by historic Center Church, built in 1887.

Facing page: Friday Harbor is located on the eastern end of San Juan Island.

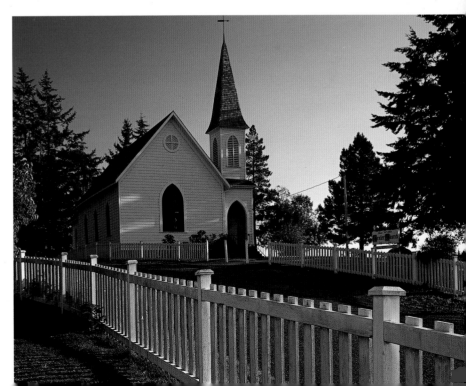

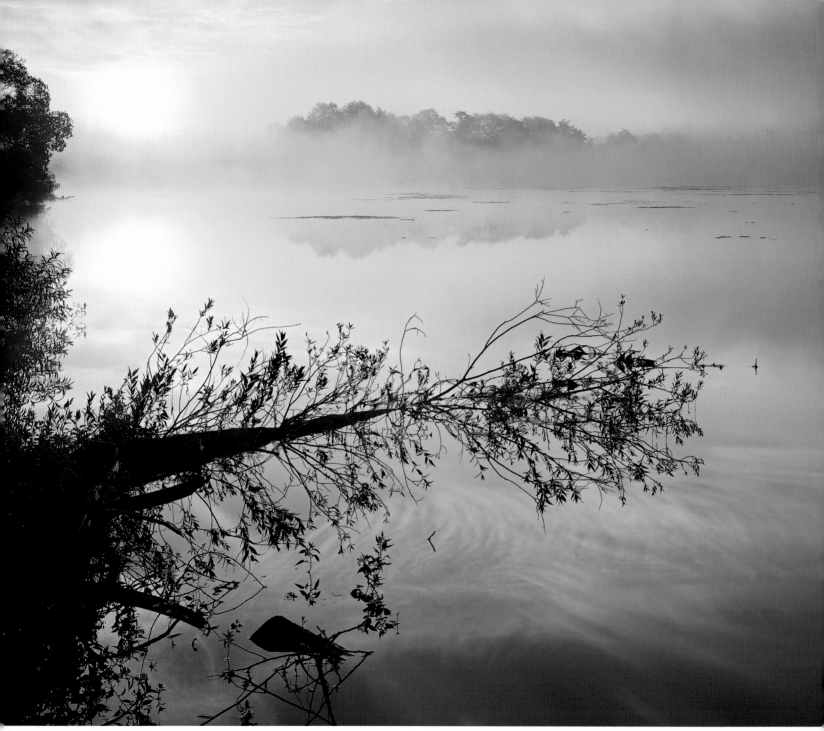

Facing page: Morning fog moves across Hummel Lake on Lopez Island.

Below: Sunrise casts a bright path of light across the water to Point Thompson on Orcas Island.

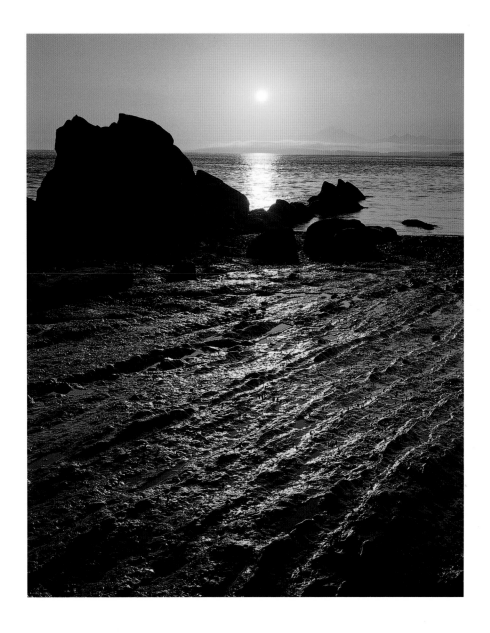

Facing page: The waters of Fisherman Bay at Lopez Island are clear and serene.

Below: Locals don their wading boots and head to the shallow waters to dig for oysters at Wescott Bay Seafood Farm on Wescott Bay. ERIC KESSLER PHOTO.

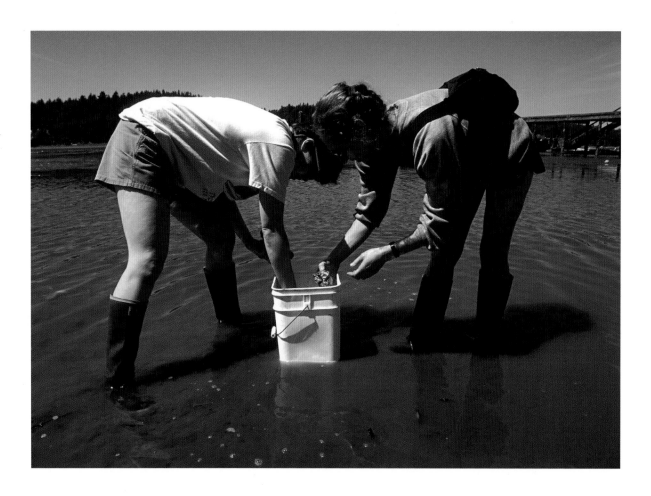

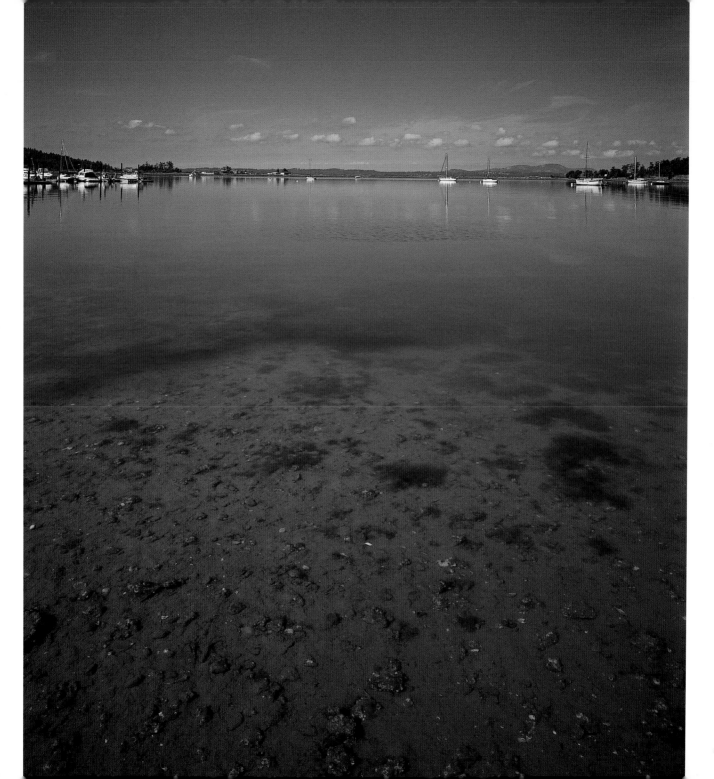

The San Juan Islands boast many charming bed-and-breakfasts and hotels, including Edenwild Inn *(below)* on Lopez Island and Orcas Hotel *(facing page)* on Orcas Island.

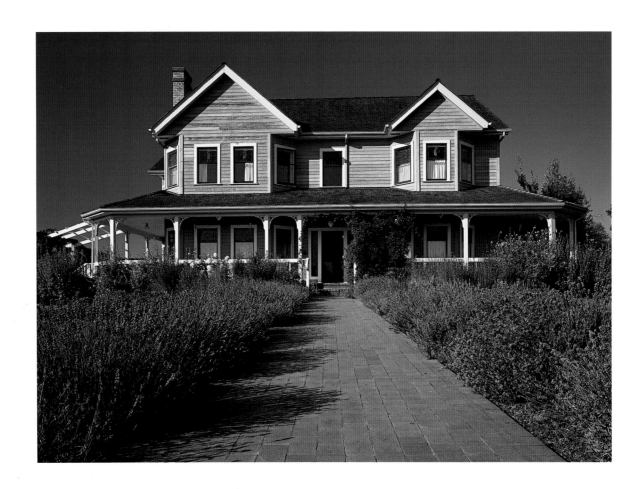

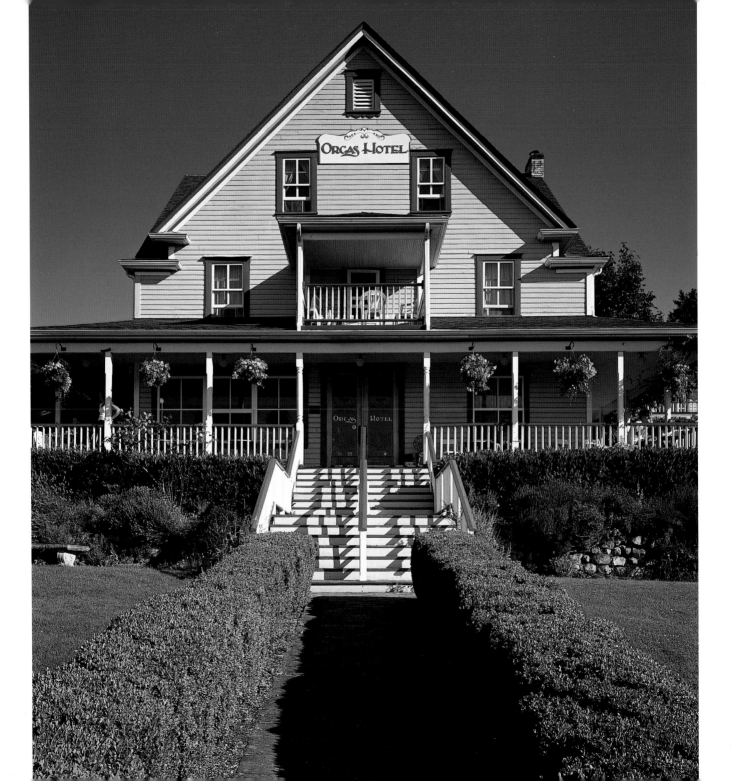

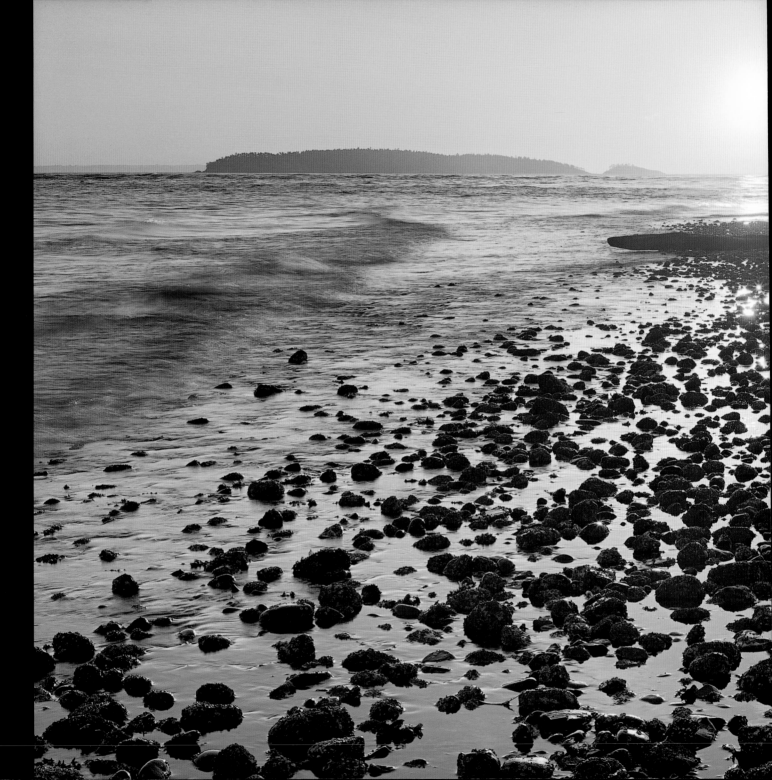

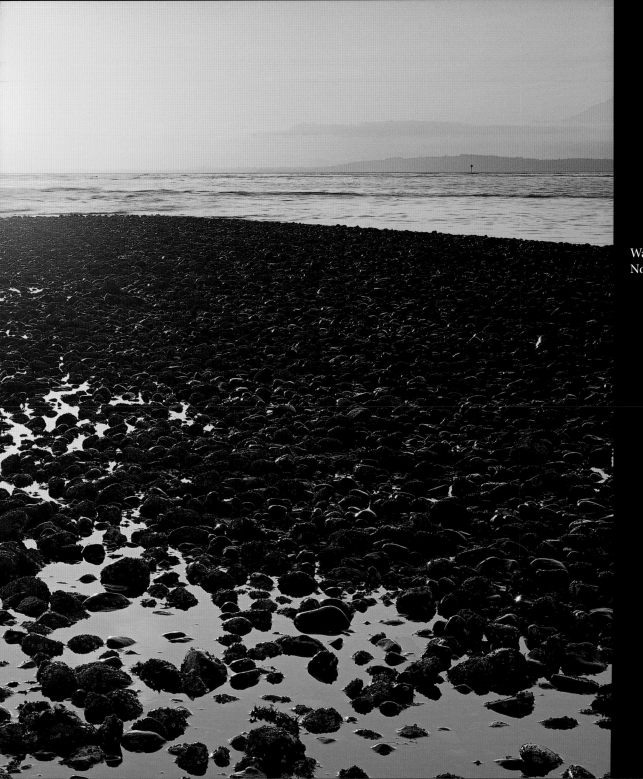

Waves lap the rocky shore at
North Beach on Orcas Island.

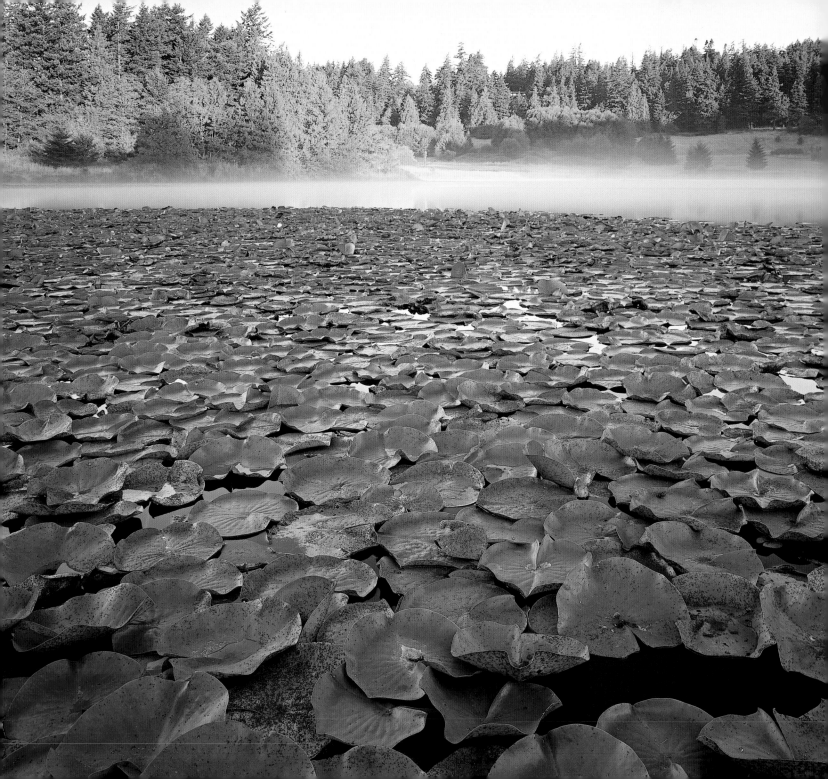

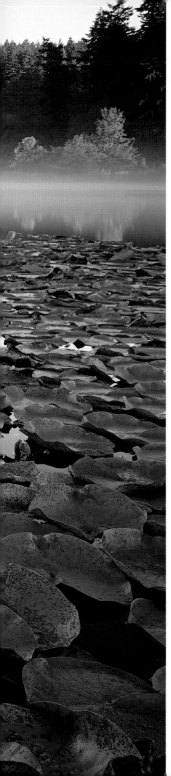

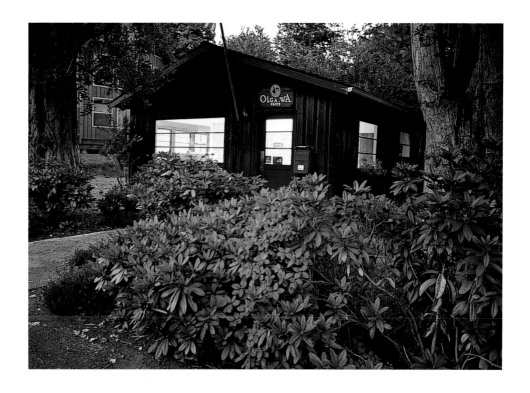

Above: The small post office in Olga serves the community on Orcas Island.

Left: Water lilies blanket Fowler's Pond Reserve on Orcas Island.

Right: It's a great day for sailing in the San Juan Channel.

Facing page: Waves roll onto shore at American Camp on San Juan Island.

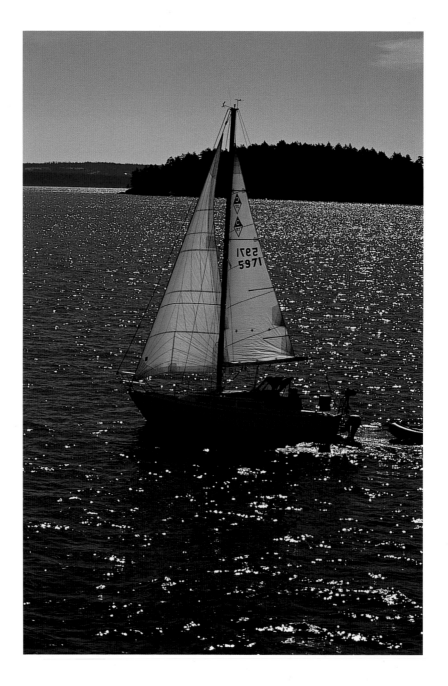

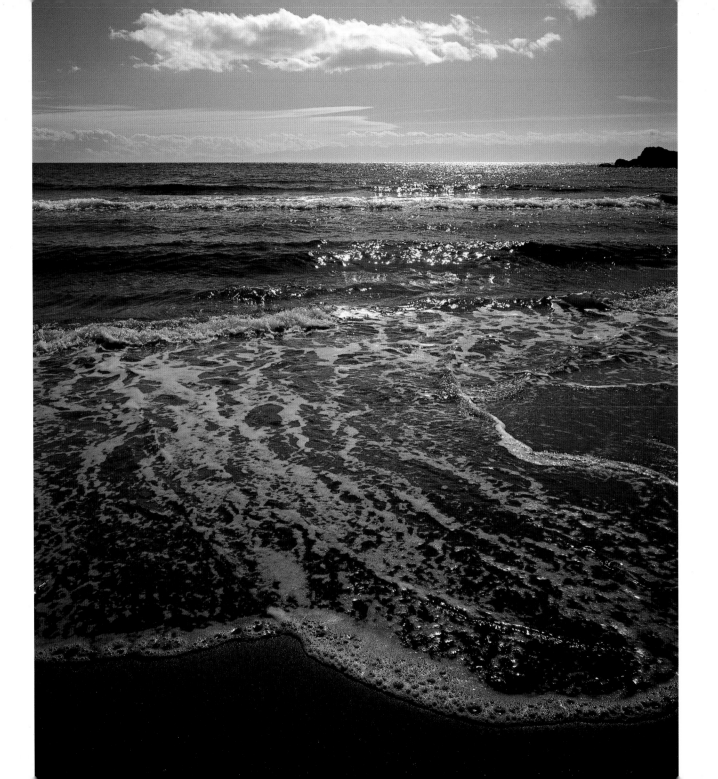

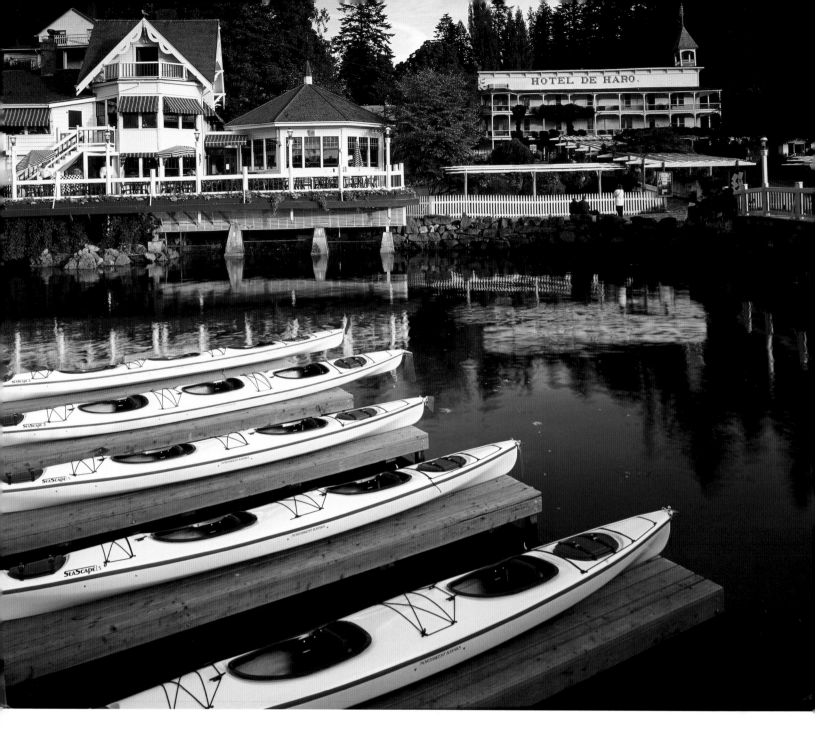

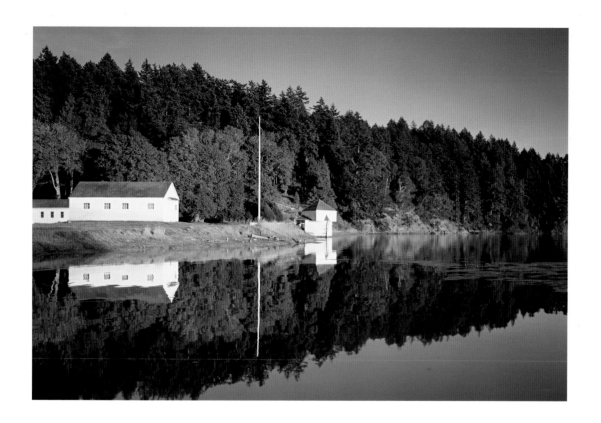

Above: The historic structures of English Camp in San Juan Island National Historical Park have changed little since they were constructed in the mid-1800s.

Right: Turn Point Lighthouse began operating in 1893 and was automated in 1974. Today, Turn Point Lighthouse State Park protects the lighthouse and the surrounding 69 acres.

Facing page: Sea kayaks are moored at the historic Hotel de Haro, located in Roche Harbor on San Juan Island.

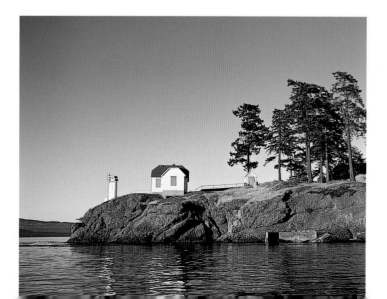

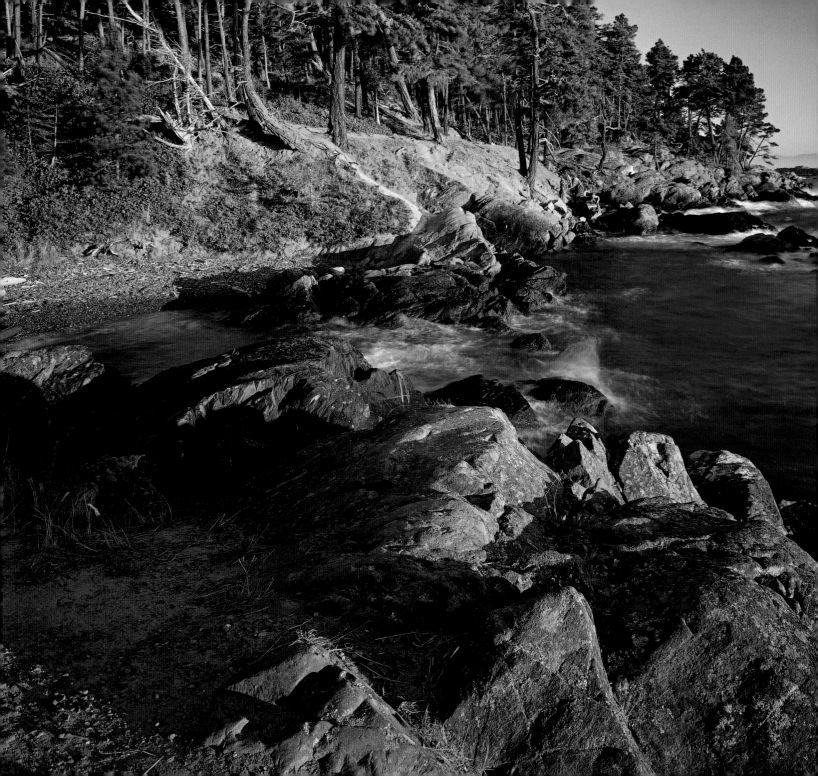

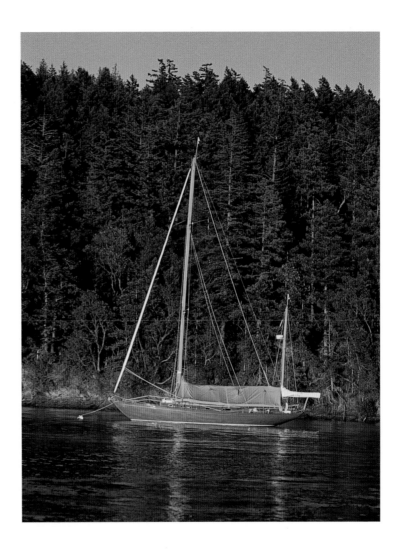

Above: This sailboat is anchored at West Sound off Orcas Island.

Left: Shark Reef Sanctuary on Lopez Island features scenic coastal vistas and 45 acres of hiking trails through old-growth woods.

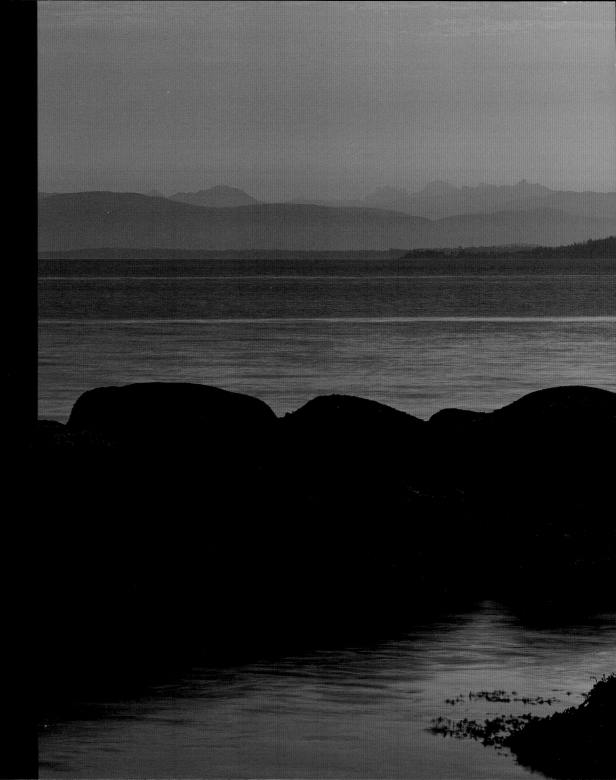

Sunset turns both water and sky a fiery red as it drops below the horizon. In this view from Point Thompson on Orcas Island, Lummi Island appears in the background, with the mainland's North Cascade Mountains in the distance. The peak at the far right is Mount Baker.

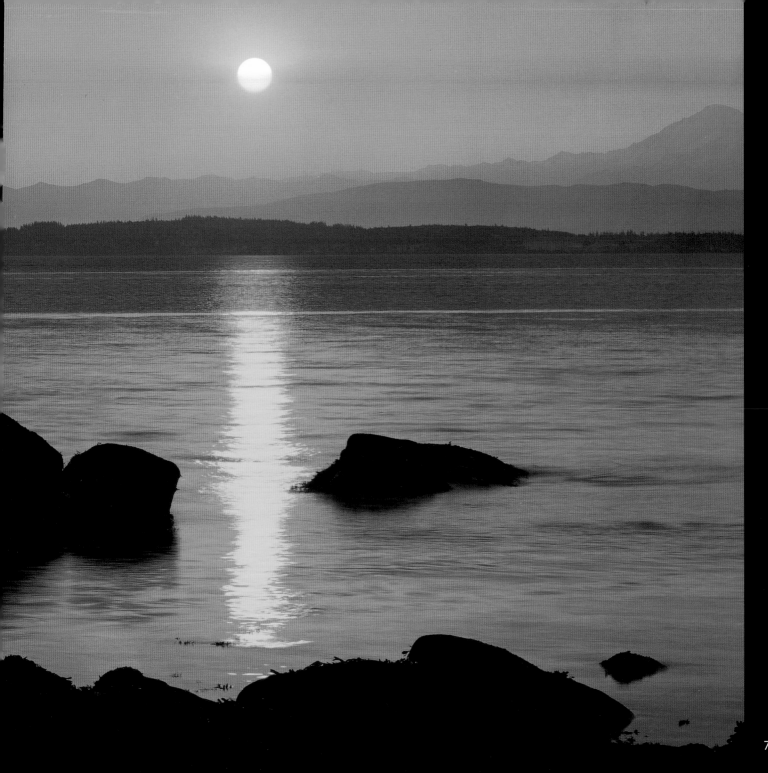

Charles Gurche is one of the United States' foremost nature and landscape photographers. His work has appeared in numerous calendars and magazines, including *Audubon, National Geographic, Natural History,* and *Outside,* and in the books *Kansas Simply Beautiful, Missouri Simply Beautiful, Oregon Impressions, Spokane Impressions, Virginia Impressions, Virginia Simply Beautiful,* and *Washington Wild and Beautiful.* He has photographed for Kodak, the Sierra Club, Smithsonian Books, and the National Park Service. Gurche has won awards from the Roger Tory Peterson Institute and the Society of Professional Journalists. View Charles Gurche's images at www.charlesgurche.com.

Visit The SeaDoc Society, a marine ecosystem health program through the UC Davis Wildlife Health Center, at www.seadocsociety.org.